PHOTOGRAPHY
A VICTORIAN SENSATION

National Museums Scotland

PHOTOGRAPHY
A VICTORIAN SENSATION

A. D. Morrison-Low

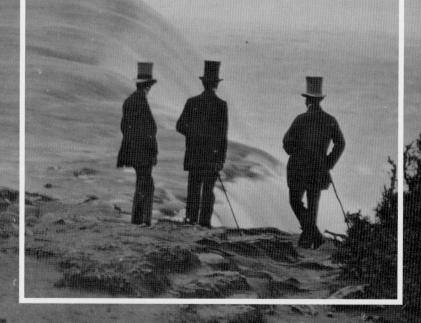

First published in 2015 by
NMS Enterprises Limited – Publishing
a division of NMS Enterprises Limited
National Museums Scotland
Chambers Street
Edinburgh EH1 1JF

www.nms.ac.uk

British Library Cataloguing in Publication
Data
A catalogue record for this book
is available from the British Library.

ISBN 978 1 905267 95 8

Book layout and design by NMS Enterprises
 Limited – Publishing
Printed and bound in Spain by Novoprint,
 SA, Barcelona

Image on cover: Cabinet portrait of an
actor Richard Mansfield as Dr Jekyll and
Mr Hyde, by Henry Van Der Weyde, London,
1878–1902. (Howarth-Loomes Collection at
National Museums Scotland, IL.2003.44.
5.25).

Image on title page: Niagara Falls, c.1855
[Fig. 2.10]. (Howarth-Loomes Collection at
National Museums Scotland).

All website addresses checked at time of
going to press.

For a full listing of NMS Enterprises
Limited – Publishing titles and related
merchandise:

www.nms.ac.uk/books

National Museums Scotland would like to thank

The Morton Charitable Trust

for their generous support of the exhibition

CONTENTS

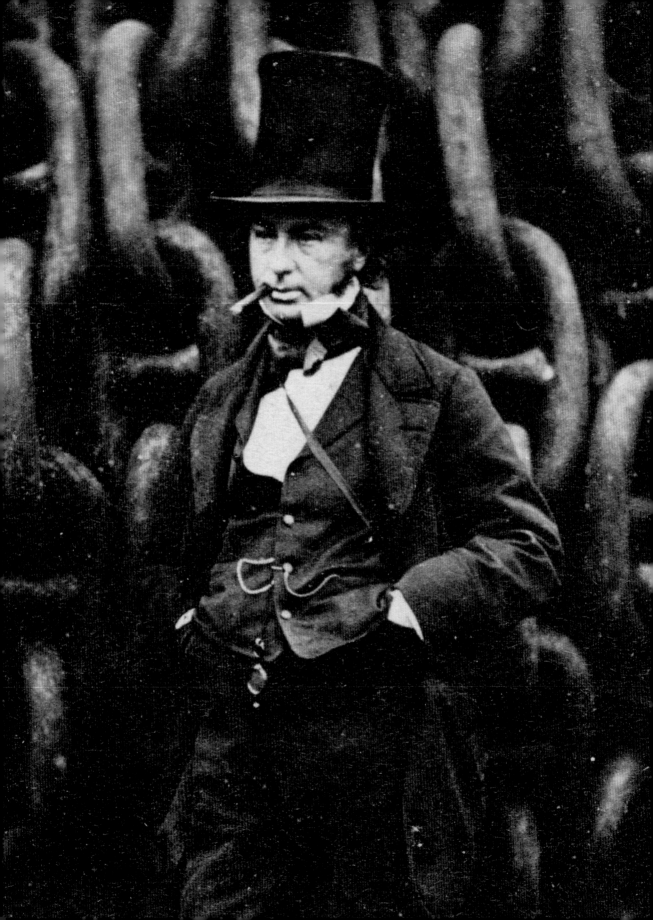

FOREWORD

Dr Henrietta Lidchi

Keeper of World Cultures
NATIONAL MUSEUMS SCOTLAND

National Museums Scotland is extremely pleased to have supported *Photography: A Victorian Sensation* through its period of gestation and research, and now its publication and exhibition. Both reflect the richness of the national collections, the way in which they cross-cut and amplify each other, bringing to our attention the equipment, the people and the photographs (in all their various forms). Progressing somewhat chronologically, identifying the photographic forms and their social uses, it fulsomely reflects the extraordinary phenomenon that was photography in the Victorian period. 'Sensation' is, indeed, a very apt term. The photographs are socially revolutionary, extraordinary in individual terms and often, on viewing, provoke a physical response, sometimes disbelief. Who can remain unmoved by the innovation and experimentation that is innate to the photographic output as seen in these pages? Or be left unaffected by the tricks they perform on the imagination when they play with reality, for example when Henry Van Der Weyde shows us simultaneously Jekyll and Hyde. Victorian photography has been analysed by cultural theory in terms of control and sometimes aggression, with figures such as Susan Sontag, Victor Burgin, Alan Sekula and John Tagg writing about the burden of representation and photography's use in documentary, science and anthropology to catalogue and control the social body. Yet what this admirably written publication evidences is the joy of photography as an experimental science and art, an aspect which the Victorians constantly played with.

Photography: A Victorian Sensation provides us with unique insight into a time when there was possibly a less complex pleasure to looking. It underscores the immediacy of photographs – what Roland Barthes describes as photography's capacity to make 'there then' into the 'here now'. The portrait of Isambard Kingdom Brunel is a case in point; the composition and his self-possession transport us directly to the humanity and aspirations of the period.

I was given the task to write this foreword in amongst many other less absorbing duties, and these quickly receded as my attention was increasingly drawn to this necessarily visual and utterly compelling history of photography. So I invite you to bask in the exhibition and publication, to relish this delightful capture of a transformative technology in continuous progression, and to witness the delight and creativity that it engendered.

Opposite page

Robert Howlett, 'Isambard Kingdom Brunel', carte-de-visite, 1857.

Howarth-Loomes Collection at National Museums Scotland
IL.2003.44.4.239

ACKNOWLEDGEMENTS

A. D. Morrison Low

Principal Curator of Science
NATIONAL MUSEUMS SCOTLAND

The exhibition *Photography: A Victorian Sensation* seems to have had an extremely long gestation period, and I must thank all those who helped it to finally appear. First and foremost, my gratitude goes to the generous people who have given cameras, photographs and equipment to National Museums Scotland in the time that I have looked after its historic photography collection. Many of these individuals are mentioned in the text, but without the generosity of Mrs Alma Howarth-Loomes, and her late husband Bernard, the exhibition that we have been able to put on in 2015 would have been immeasurably the poorer.

Over the years that it has taken to assemble the thoughts about these collections, I must thank colleagues, past and present. These include, outside the walls of National Museums Scotland, John Ward, formerly of the Science Museum, London, and Sara Stevenson, formerly of the National Galleries of Scotland. Over the years, the Scottish Society for the History of Photography has proved immensely supportive and for this I must thank Alex Boyd, David Bruce, Ray McKenzie, Monica and Nigel Thorp, Julie Lawson and Roddy Simpson.

Within National Museums Scotland, I am grateful to Henrietta Lidchi, Alex Hayward, Jane Carmichael, Jim Tate, Kathy Eremin, Sheila Masson, Kirke Kooke, Chelsea Clarke, Malcolm Shanks, Neil McLean, Joyce Smith, Scott Caldwell, Graeme Yule, Maureen Kerr, Julie Orford, Victoria Adams, Christine Maclean, Alison Cromarty, Sarah Teale, Esther Titley, Jan Dawson, Tom Chisholm, Steven Anderson, Stuart Jack, Karen Inglis, Katie Robson, Hugh Wallace, Elaine Macintyre, Victoria Hanley, Lisa Cumming, Rosalind Bos, Emmanuelle Largeteau, Diana McCormack, Diana de Bellaigue, Amy Romanes, Gerald Rafferty, Alice Wyllie, Brian Maycock, Anne McMeekin, Paul Wareham, Charlotte Neilson, Kate Blackadder, Lynne Reilly, Helen Osmani, Margaret Wilson and Lesley Taylor, the Library, and other staff of National Museums Scotland.

It has been a pleasure and a privilege to work with colleagues – and material – of the highest calibre. Thank you all.

IX

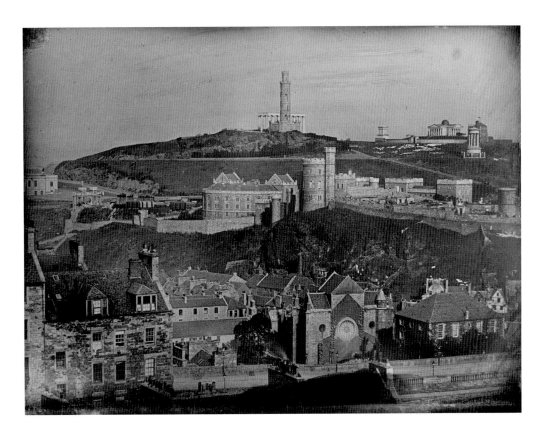

Above

View of Calton Hill, Edinburgh, probably from the window of Thomas Davidson's premises just off the Royal Mile. Modern print of whole plate daguerreotype attributed to Thomas Davidson, *c.*1840.

National Museums Scotland T.1938.104

PART 1

ORIGINS AND SOURCES

of the Photographic Collections

When death comes … you can take out these,
it may be, wasted, shadowy, almost vanishing images –
how you treasure them forever, beyond all trim
and graceful miniatures by man's hand.

*

Anonymous (presumed to be John Brown), review of the
Photographic Society of Scotland's exhibition, 1862

THE historic collection of photography at National Museums Scotland is unusual in that it contains both apparatus and images – the latter as examples of processes, rather than as art (as collected, for instance, by the National Galleries of Scotland). Since its invention, when photography was eagerly appropriated by the wealthiest members of society, with subsequent technical improvements, it mushroomed into an industry, became much more widely and socially available, and was used as an increasingly indispensable tool by other sciences and industries. Soon the world was saturated with images of society, war and far-off countries. The collection at National Museums Scotland attempts to reflect this burgeoning of size and multiplicity of purposing.

People have always wanted to remember their loved ones and loved places, especially if death or distance intervened. Until about 175 years ago, only the wealthy were able to possess paintings of their families and estates [**Fig. 1.1**]. This all changed with the advent of photography in 1839; but even this new scientific art-form had its own back-story; and its delivery was not straightforward either. This exhibition attempts to provide some context for the arrival of photography in its earliest forms, leading up to the year 1851 when such forms were showcased in the Great Exhibition of All Nations, held in London's Hyde Park. This was, coincidentally, the same year that a new, faster, more commercial form of photography – the wet collodion process – was invented and given freely to the world. The exhibition also explains how the world was captivated by these new images, seemingly unmediated by an artist's interpretation; it looks at the technologies as they developed towards the end of the 19th century, and touches upon the desire of the photographic consumer for increasingly life-like improvements – colour, three dimensions – to what was becoming an increasingly popular and industrialised product.

In the years after the Great Exhibition, some of these potentials were realised: but colour photography – as opposed to 'tinting' a monochrome image – was not to become a practical or commercial reality until just before the First World War. Stereoscopy seems to be discovered, and then rediscovered, by successive generations – the 1850s, 1890s, then again between the First and Second World Wars: indeed some of us may recall

Page x–1

J. W. Ebsworth, 'North View of Edinburgh, from the Upper Gallery of the Scott Monument …', showing James Howie's rooftop studio, September 1845.

Howarth-Loomes Collection at National Museums Scotland IL.2003.44.8.91

Fig. 1.1 (opposite)

Unknown artist, John Macdonald of Clanranald, miniature painting, c.1790.

National Museums Scotland H.MCR 65

the craze of the View-Master images of the 1950s and '60s, while more of us remember those books available in the 1980s where 'free-viewing', without any apparatus, enabled one to resolve images hidden in the pages (or not as the case may be). More recently, a three-dimensional effect has been applied to television and the cinema. New photographic processes, without using silver salts – which had been discovered in the year of photography's birth, 1839 – were developed to enable both the production of images alongside printed text on the same page, as well as the making of cheaper photographs and fresh applications.

National Museums Scotland made the decision that the display would highlight its own collections, which have not been shown in this way before. In a few instances there are loans from other institutions, especially in the early period, but we are fortunate that the collections held at the Museum are extremely rich and diverse. Perhaps the earliest items to come into the collections are two albums owned by the Society of Antiquaries of Scotland. One album, presented by the artist David Octavius Hill in 1851, contains 110 salt prints using W. H. F. Talbot's calotype process, but made by Hill in partnership with Robert Adamson between 1843 and the latter's early death in 1848. The second album contains images presented that same year by James F. Montgomery, made by the same process, which is associated with many of the images created by a group of Edinburgh lawyers and doctors who formed an informal society known as the Edinburgh Calotype Club.[1] This was the world's first photographic society.

National Museums Scotland's other collections of the history of photography have been closely allied with its science and technology collections. The first camera was acquired in 1899 and sectioned (cut in half) to show 'how it worked', along with a microscope, telescope and pair of binoculars which were similarly sectioned.[2] Over the years more substantial and important acquisitions have been added, with examples of processes brought in to show differing end products. The Scottish 'national' collection of photographs resides with the National Galleries of Scotland, where – building on a substantial collection of material by the pioneers Robert Adamson and D. O. Hill – the Scottish National Photography Collection was formed in 1989.[3]

Perhaps photography – an art-form invented using science and technology only after the Enlightenment encyclopaedists had categorised all forms of human activity – has fallen into a form of unpigeonholed limbo, a situation exacerbated by the arguments of early practitioners. It came from scientific roots: the chemistry of silver salts blackening in sunlight married to the images captured in the optics of the portable camera obscura, and fixed by yet more chemistry into a permanent picture [**Fig.**

1.2]. Today we are so engulfed in imagery, both still and moving, that we may give little thought as to where we might place photographic technology or its products, unless we work in a museum or art gallery. In the end, is this important?

Just as there are many histories of art, so there are a number of histories of photography. The history of photography that we often see displayed in galleries and museums tends to reflect the art of photography. Thanks to the broad nature of the National Museums Scotland's collections, another, more technological and economic, history can be outlined: and this exhibition looks at the beginnings of an important and relatively recent technology that has profoundly affected all our lives, especially how we see the world. But this is not to say that the artistic products of the surrounding world have been ignored: and for the first time, the Victorian world was newly opened up so that it could be examined from the safety of the viewer's armchair.

One of the Museum's early camera acquisitions was a gift of an unsigned early daguerreotype camera, donated in 1925 by one James Adams of Dunfermline, about whom nothing further is known [**Fig. 1.3**]. Despite being unsigned, this metal instrument was probably a prototype made by the Edinburgh pioneer camera maker, Thomas Davidson, who made photographic apparatus for, among others, David Brewster and Hill and Adamson.[4] In 1936, the Museum was given a world-class selection of extremely early and significant material, both images and apparatus, by the granddaughter of the originator of positive-negative photography himself, William Henry Fox Talbot, of which more will be said.[5] Then, during the Second World War, the Museum was presented with the St Andrews photographic pioneer Dr John Adamson's calotype albums, given in 1942 by Adamson's son and grandson.[6] Other photographic items accrued over time in an *ad hoc* and not very organised way, so that by the early 1980s the collection needed a bit of thought and some structure.

Thinking was done, advice was sought, and the Museum acquired some landmark items at auction in the early 1980s: a Dubroni outfit [**Fig. 1.4**], where the wet collodion image is processed inside the camera; an ancestor, perhaps, of the Polaroid camera of the mid-20th century. The Museum has also collected a representative selection of these, including an example of the SX-70 presented by Polaroid (UK) Ltd.[7] A single-lens

Fig. 1.2

Reflex camera obscura, mahogany box, by W. & S. Jones of London, early to mid-19th century.

National Museums Scotland T.1993.8

Fig. 1.3

A metal daguerreotype camera, unsigned, but to the design of Thomas Davidson, *c*.1840.

National Museums Scotland T.1925.16

5

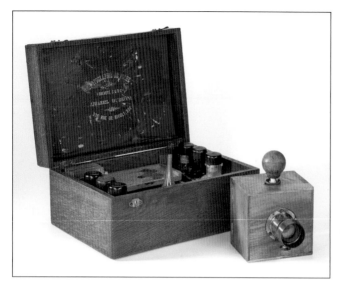

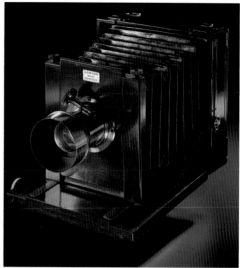

Fig. 1.4 (above left)

Small Dubroni camera in brass and wood with integral processing, in a carrying box with chemicals and accessories, made by G. J. Bourdin of Paris, c.1867.

National Museums Scotland
T.1982.149

Fig. 1.5 (above right)

Half-plate folding camera sold by Lowdon, Dundee, c.1855, with a lens made by Andrew Ross, London.

National Museums Scotland
T.1981.41

stereo camera outfit by Thomas Ottewill of London was also acquired, and this satisfactorily complements the earlier twin-lens stereo camera by J. Dallmeyer that had been donated to the Museum in 1967.[8] In 1981, a fine folding wooden camera dating from about 1855, retailed by the Dundee maker George Lowdon, with a lens by Andrew Ross of London [**Fig. 1.5**], was presented to the Museum in the Arthur Frank Collection of Scientific Instruments.[9] In 1982, with the launch of the ill-fated Kodak Disc camera, consumers were encouraged to exchange their old cameras for the new device. Kodak UK sent these to the Kodak Museum in Harrow, where the curator Brian Coe selected a group to add to the collections there; John Ward, photography curator at the London Science Museum, chose items to enhance those of his institution; and a third group – mostly of post-Second World War cameras, from the cheaper end of the range – came to the collections in National Museums Scotland.[10]

In the past quarter century or so, the Scottish national collections of photographic instruments and apparatus have been boosted by one particularly significant group of material – the Howarth-Loomes collection – as well as innumerable smaller but no less important gifts and acquisitions, and it continues to grow.

The Howarth-Loomes Collection

The arrival of the Howarth-Loomes Collection has transformed the historic photographic collections in the National Museums of Scotland. This exhibition has enabled us, for the first time, to explore and share some of the delights of this wonderful and varied treasure trove, which dovetails so well with material already in the Scottish national collections. Bernard Howarth-Loomes and his wife, Alma, put together a magnificent and enormous collection of principally stereoscopic material, including a number of unusual viewers: this came to the Museum in 2003 shortly after Bernard sadly died. He is remembered as a colourful and somewhat mischievous figure.[11] The sole description of the Howarth-Loomes Collection across all its components to date remains the book produced by Bernard Howarth-Loomes in 1973.[12] This was a discussion of his collection some thirty years before his death. In this book, he and Alma tried to help other collectors, especially beginners in the field, with some signposting of historic landmarks in photography. The Howarth-Loomes Collection is by no means exclusively stereoscopic in its content, and covers the entire range of 19th-century photography. It contains some marvellous stereo daguerreotypes, many outstanding ordinary daguerreotypes, including some examples made into jewellery, and also includes a whole plate scene of Niagara Falls by Platt D. Babbitt.[13]

The Howarth-Loomes Collection encompasses large numbers of ambrotypes and tintypes, both positive processes derived from the wet collodion process. There are thousands of cartes-de-visites, including (for instance) the famous portrait by Robert Howlett of the engineer Isambard Kingdom Brunel, taken against the chains of the *Great Eastern* [**Fig. 1.6**].[14] There is also a substantial quantity of pre-photographic equipment: for example, a couple of Claude Lorraine glasses, several kaleidoscopes and a number of devices that move or deceive the eye into believing a false 'reality', such as zograscopes, polyrama-panoptiques, praxinoscopes, zoetropes and phenakistascopes.[15] Not only are these rather unusual pieces in first-rate condition, but there are associated contemporary prints and ephemera, the social documentation of which rarely survives and has taken dedicated and unceasing collecting to draw together.

Fig. 1.6

Robert Howlett, 'Isambard Kingdom Brunel', carte-de-visite, 1857.

Howarth-Loomes Collection at National Museums Scotland IL.2003.44.4.239

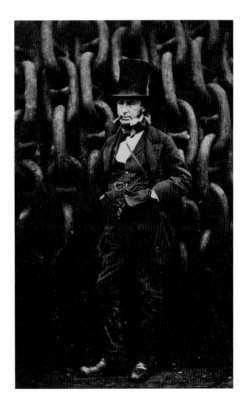

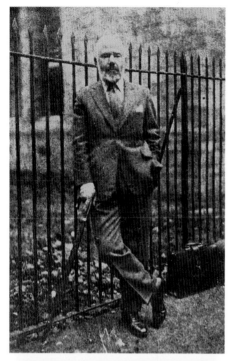

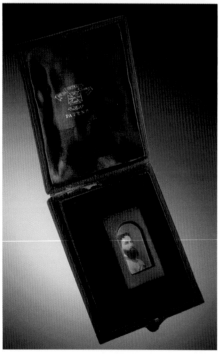

Bernard Howarth-Loomes [**Fig. 1.7**] began collecting photography through the interest of an older friend of his, who had been a sort of guardian figure to him, N.D. Larkin. 'N.D.' Larkin had started a photographic studio with his brother in about 1919, and was a very good commercial photographer.[16] Larkin was particularly keen on stereo photography as a means by which commercial travellers could sell their wares, by showing a prospective client a three-dimensional view of the items for sale. He owned a Brewster viewer. Bernard saw a stereographoscope in an antique shop and acquired it; N.D. gave him the Brewster viewer to 'go with it'. Bernard – who, Alma says, could lose interest in subjects that had previously inspired him – never lost interest in stereo photography. Instead, his interest expanded, and became almost a 'disease'; in fact, says Alma, both of them were infected with enthusiasm in the early days (the late 1960s) of their collection. Photographic and stereophographic material was still difficult to find in these early days, difficult because no one was collecting and dealers did not rate it. In Birkenhead on one occasion, Bernard only managed to acquire some items because the dustmen had not yet made their rounds![17]

When the Arts Council exhibition held their exhibition, 'From Today Painting is Dead', in the Victoria and Albert Museum in 1972, and Sotheby's began to hold their first regular photographic auctions, collecting photography took off as a subject. People learned quickly; for instance, Bernard was able to acquire a Swan casket [**Fig. 1.8**] for relatively little because no one knew what it was; but by the subsequent auction, another example was correctly described and reached considerably more.

For a long time, the Howarth-Loomeses did not spend more than £5 on an item, and often travelled miles and miles finding nothing. The collection began to take over their lives: holidays were now taken only in places which had antique shops, and often the 'sights' were not visited in favour of searching out possible items. Bernard began going to London's Bermondsey Market from the late 1960s, rising at 3 am on Friday mornings. At this point, lots of good material was passing through: on one

occasion Bernard was chased through the market by a dealer with a box of stereo cards for £5: but Bernard was not sure! At that date, stereo cards sold for 1d or 2d, but dealers did not recognise stereo daguerreotypes. On another occasion, Bernard was offered a box containing cards with a group of stereo daguerreotypes thrown in, as the dealer was not sure what they were.

Bernard Howarth-Loomes clearly enjoyed the chase, and could become extremely vexed if beaten to a sale by another collector; however, he would make it up eventually, as in those early days the collectors all knew one another and were very friendly. At the very first Sotheby's photographic auction in London in 1967, the Howarth-Loomeses knew everyone in the room and they were all on good terms.[18]

The Howarth-Loomeses followed no guidelines to collecting in the early days, but if an item on offer was vaguely photographic or optical, then they bought it. For instance, Alma remembers seeing a polyrama-panoptique offered for 12/6d, which looked interesting, but neither knew what it was. It was as much a learning experience as a collecting one.

In 1972, Bernard loaned material to the influential exhibition, 'From Today Painting is Dead';[19] and afterwards he lent items to the Science Museum and the Kodak Museum, and he liked to see his things on public display. He also passed on items he did not want to relevant collections, and was always very generous in helping, lending, sending things on. Many illustrations of items from their collection have appeared in publications over the years.[20] He and his wife have been particularly generous ensuring that their collection, put together over many years, has come to National Museums of Scotland; and Alma, in promising that it will eventually become a bequest in due course.

9

Fig. 1.7 (opposite above)

Richard Morris, Bernard Howarth-Loomes standing in the grounds of the Natural History Museum, London, salted paper print from a calotype negative, 1969.

Howarth-Loomes Collection at National Museums Scotland
IL.2003.44.9.92

Fig. 1.8 (below)

A Swan's patent Casket portrait of a bearded gentleman, 1862.

Howarth-Loomes Collection at National Museums Scotland
IL.2003.44.10.222

Notes

1. Both of these are held by National Museums Scotland Library: ATTIC TR 140 Hil, vols 1 and 2.
2. National Museums Scotland (NMS) T.1899.1: 'Whole plate box camera cut to show half section of the lens combination and interior of the camera.'
3. Sara Stevenson and Duncan Forbes 2001. *A companion guide to photography in the National Galleries of Scotland* (Edinburgh: National Galleries of Scotland), 7–8.
4. NMS T.1925.16: see A. D. Morrison-Low, 'Instrument making and early photography', *Photohistorian*, the Newsletter of the Royal Photographic Society 149, January 2007: 29–37.
5. NMS T.1936.21–38, 85–108, 114, and T.1937.90–92: discussed by Larry J. Schaaf, '"Do not burn my history": the physical evidence of W. H. F. Talbot's creative mind', in Bernard Finn (ed.) 2004. *Presenting Pictures* (London), 129–45. Some of these items are also discussed in A. D. Morrison-Low, '"Tripping the Light Fantastic": Henry Talbot and David Brewster', *Studies in Photography* 2002–3: 83–8.
6. The albums have inventory numbers NMS T.1942.1.1 and 1.2, for which see A. D. Morrison-Low, 'Dr John and Robert Adamson: an early partnership in Scottish photography', *Photographic Collector* 4, 1983: 199–214, subsequently republished as 'Brewster, Talbot and the Adamsons: the Arrival of Photography in St Andrews', *History of Photography* 25:2, 2001: 130–41.
7. NMS T.1983.74.
8. The Ottewill & Co. camera (NMS T.1981.20) and the Dallmeyer item, no. 495 (NMS T.1967.176), were both illustrated in A. D. Morrison-Low and A. D. C. Simpson, 'A New Dimension: a Context for Photography before 1860', in Sara Stevenson (ed.) 1995. *Light from the Dark Room* (Edinburgh), 15–28.
9. NMS T.1981.41, discussed, along with other items from Lowdon's workshop, in T. N. Clarke, A. D. Morrison-Low and A. D. C. Simpson 1989. *Brass & Glass: Scientific Instrument Making Workshops in Scotland* (Edinburgh), 146–51.
10. In time, the first two collections have become a part of the National Media Museum, part of the National Museum of Science and Industry, in Bradford. See Colin Harding 2009. *Classic Cameras* (Lewes: Photographers' Institute Press). For the story of Kodak Disc camera, see Todd Gustavson 2011. *500 Cameras: 170 Years of Photographic Innovation* (New York: Sterling Publishing Co., Inc.), 382.
11. Arthur Middleton, 'Market Place Autumn 2003', *Bulletin of the Scientific Instrument Society* 78, 2003: 31.
12. B. E. C. Howarth-Loomes 1974. *Victorian Photography: a Collector's Guide* (London: Ward Lock Limited). Recently, the National Monuments Record (based in Swindon), which holds copies of all stereo cards with English subjects from the Howarth-Loomes Collection, published Ann Saunders 2008. *Historic Views of London: Photographs from the Collection of B. E. C. Howarth-Loomes* (Swindon: English Heritage). Staff of National Museums Scotland have been listing and researching the collection's contents since 2003.
13. Platt D. Babbitt (1827–72) ran a photographic studio at Niagara Falls for many years: <http://www.getty.edu/art/gettyguide/artMakerDetails?maker=2841>
14. Copies of the Howlett images from the Howarth-Loomes Collection were lent to the London Science Museum's exhibition 'Fame and Fortune' in May 2006 to celebrate the bicentenary of the great engineer.
15. For a general history of these devices, see, for instance, Laurent Mannoni and Werner Nekes 2004. *Eyes, Lies and Illusions: the Art of Deception* (London: Hay-

ward Gallery Publishing); or Barbara Stafford 2001. *Devices of Wonder: from the World in a Box to Images on a Screen* (Los Angeles: Getty Research Institute).

16. N. D. Larkin and R. F. Larkin, *British Journal of Photography* 117, 1970: 466.

17. This section is based on notes taken by A. D. Morrison-Low in an interview given by Mrs Alma Howarth-Loomes, February 2004.

18. <http://www.sothebys.com/en/departments/photographs/records.html> – 'History of Success'.

19. D. B. Thomas 1972. '"From Today Painting Is Dead": The Beginnings of Photography' (London: Arts Council of Great Britain): exhibition at the Victoria and Albert Museum, London, 16 March to 14 May 1972.

20. For instance, in Roger Taylor 1981. *George Washington Wilson, Artist and Photographer, 1823–93* (Aberdeen: Aberdeen University Press in association with the University of Aberdeen).

Below

A quarter-plate daguerreo-type of George R. Gliddon (1809–57) by Matthew Brody (*c.*1822–96) of New York, 1853–54.

Howarth-Loomes Collection at National Museums Scotland IL.2003.44.2.11

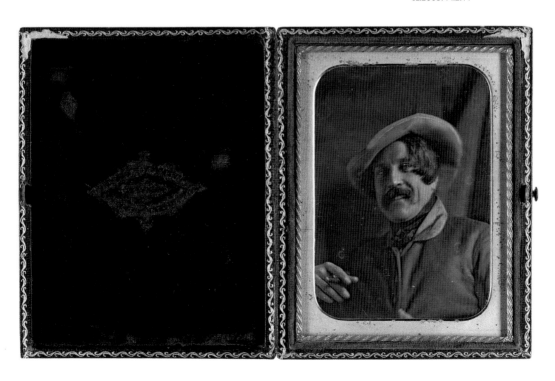

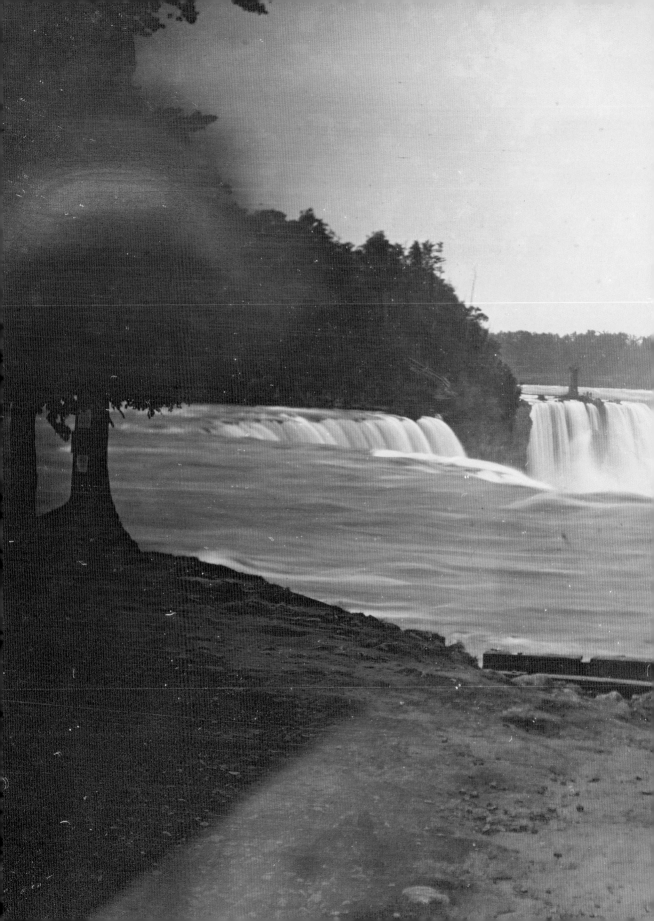

PART 2
FIRST IMAGES
Daguerreotypes

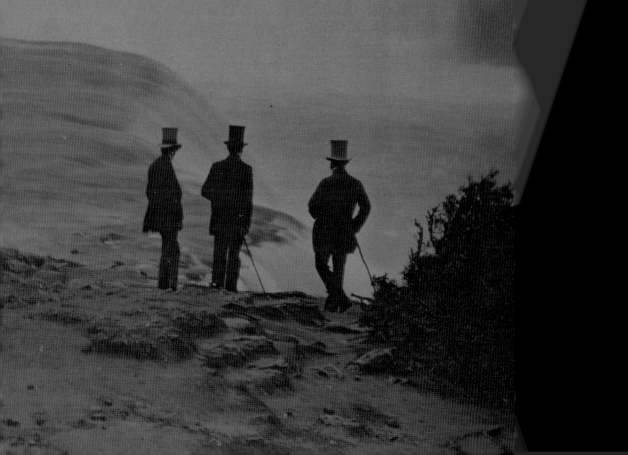

I have seized the light and arrested its flight!
The sun itself shall draw my pictures!

*

Louis Jacques Mandé Daguerre
in a letter to Charles Chevalier, 1839

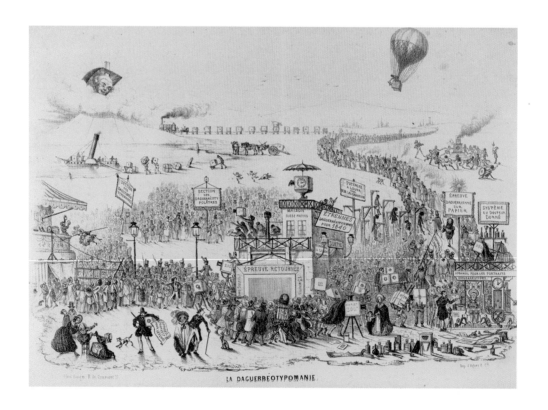

LA DAGUERRÉOTYPOMANIE

THE first successful form of photography – the daguerreotype – was the result of many years of painstaking optical and chemical experiments by its inventor, the Frenchman, Louis Jacques Mandé Daguerre (1787–1851), and resulted in a single, reversed positive image, in the form of molecules of a silver-mercury amalgam resting on a polished metal plate. Its fragility meant that it had to be protected by both a matt, and a glass cover, held together in a frame: a small and precious object, unique in its production. In order to have multiple images, further exposures had to be made. The arrival of the daguerreotype in Britain was a successful demonstration of delayed gratification; it did not immediately burst into life, shining like a beacon. Instead, it was almost doused by legality, and this difficult delivery is perhaps reflected in the ambivalence shown towards it by photographic historians.

Articles began to appear in the London press in late January 1839, describing the excitement generated in Paris by a paper read by the well-known French astronomer and scientist François Arago before the Académie des Sciences; this interest was 'so universal' that the unnamed corres-pondent of the *Athenaeum*, a leading London literary journal, 'called on M. Daguerre, to possess myself, as far as was permissible, of the facts of his very remarkable discovery, and to add to a report of what has been said on the subject, after a few details of what I had seen'.[1] Stress was made on the long and arduous experiments made by Daguerre, reminding the reader that this was the same man who had produced the diorama, which was then showing in both London and Paris.[2] The correspondent wrote:

> Briefly to explain it, it enables him [Daguerre] to combine with the *camera obscura* an *engraving power* – that is, by an apparatus, at once to receive a reflection of the scene without, and to fix its forms and tints indelibly on metal in *chiaroscuro* – the rays of the sun standing in the stead of *burin*, or, rather, acid – for the copies thus produced nearly resemble aquatinta engravings exquisitely toned … of course, I can as yet give you no precise details, as M. Daguerre naturally objects to impart them to any one, till he has received some definite answer from the [French] Government, with whom he is in treaty for the sale of his secret ….[3]

Pages 12–13

Whole plate daguerreotype of the Niagara Falls with three men in top hats in foreground, c.1855.

Howarth-Loomes Collection at National Museums Scotland IL.2003.44.2.83 (detail)

Fig. 2.1 (opposite)

Théodore Maurisset, 'La Daguerréotypomanie', litho-graph, 1839.

Howarth-Loomes Collection at National Museums Scotland IL.2003.44.8.90

16

By July 1839 it was reported that an annual pension of 6000 francs
had been awarded to Daguerre and one of 4000 to the son of Niecéphore
Niépce (Daguerre's co-experimenter, Niecéphore Niépce, had died in 1833)
'in consideration of their making public the discovery respecting which so
much has been lately written, and of which, therefore, something will now
shortly be known'.[4] These negotiations had taken most of the year, and
only when completed was Daguerre prepared to divulge the secret of his
process. François Arago acted as Daguerre's mouthpiece before the Acad-
émie des Sciences – 'in the presence of a crowded audience, which had
besieged the doors of the Institute three hours before the commencement
of the sitting' – and in a bulletin dated 21 August, the method was, at last,
outlined in print to an English audience.[5] Indeed, the enthusiastic Parisian
crowds were such that cartoons were made of the madness of the world –
one of the most famous of these being 'La Daguerréotypomanie', a litho-
graphic print by Théodore Maurisset for *La Caricature* and published on 8
December 1839 [**Fig. 2.1**].[6]

This amusing and detailed cartoon is a fantasy of the future of photo-
graphy as an industrialised process, foretelling the end of the career of
engravers, who are invited to hang themselves on the gallows provided in
the centre of the image. Théodore Maurisset (1803–60) was an engraver,
artist and lithographer, and this is his most famous
work.[7] It imagines how photography will take over
the world: it aligns photography with surveillance,
so that even the sun (who has the face of François
Arago) has turned into a vigilant camera. The balloon
above (this is, of course, decades before the inven-
tion of the aeroplane) is also a watcher in the sky.[8]

Efforts were made to turn the daguerreotype
into an engraving plate – and some early success
was achieved by the French physician Alfred François
Donné (1801–78). He displayed his pale prints from
etched daguerreotypes to the French Academy of
Science in 1839. His process used the natural grain
and acid-resisting properties of the mercury amal-
gam to etch the silver plating from the open shadow
areas on the surface of the plate.[9] However, the re-
sults were faint, and the unique plate was destroyed
after a run of about 30 prints, so that this process was
rapidly abandoned. Most 'reproductions' of daguer-
reotype plates thus had to be some sort of engrav-
ing. Among the most famous of these was a book of

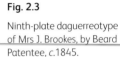

engravings based on daguerreotypes, organised by the Parisian optician Noel Marie Paymal Lerebours (1807–73), which was produced in a series of subscription parts between 1841 and 1864, showing views of Paris, Rome and the Niagara Falls [**Fig. 2.2**]. The original daguerreotype of one of these engravings still exists.[10] The engravings have had details of everyday life added to them, as the exposure time was too long to allow these to register. It is possible that the detail of a photographer in front of the 'Portail de Notre Dame de Paris' is of Lerebours himself!

In France, the daguerreotype process was given freely to the world; but, just before this was announced, the inventor Daguerre had made sure – for whatever reasons – that he had secured that his process was patented in England. Although he also took out a patent to cover Scotland, this was never enforced.[11] This meant that would-be English practitioners there were obliged to obtain a licence, and thus the process began with only two licensees in London: Richard Beard (1801–85), an entrepreneur who subsequently obtained a monopoly on the process [**Fig. 2.3**]; and Antoine Claudet (1797–1867), who had learned the procedure from Daguerre himself [**Fig. 2.4**].

One of the English amateurs who bought himself daguerreotype equipment was a country gentleman with scientific inclinations named William Henry Fox Talbot (1800–77) – in fact, he preferred a shortened form of his name, Henry F. Talbot – who was based at his country seat, Lacock Abbey in Wiltshire. Talbot was actively pursuing his own attempts to capture images chemically seen through the camera obscura, spurred into action by Daguerre's announcements. An invoice, dated 10 October 1839, from the Parisian business Alphonse Giroux et cie, stationers, survives in Talbot's correspondence. This had been forwarded on to Talbot by the London firm of Andrew Ross, listing 'two camera obscurae for Daguerreotypes with their lenses', costing £310 for both (with a six per cent reduction).[12] Giroux was related to Daguerre's wife and in August 1839 he secured the exclusive contract to market daguerreotype cameras and outfits manufactured under Daguerre's supervision. With no optical experience, Giroux turned to Parisian optician Charles Chevalier to make the lenses.

The previous day, Talbot had written from his London base to the mathematician and astronomer,

Fig. 2.3

Ninth-plate daguerreotype of Mrs J. Brookes, by Beard Patentee, c.1845.

Howarth-Loomes Collection at National Museums Scotland IL.2003.44.2.332

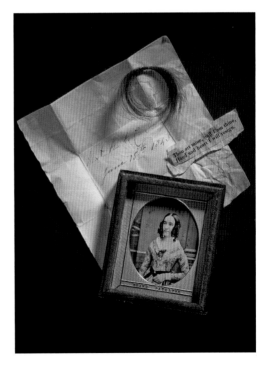

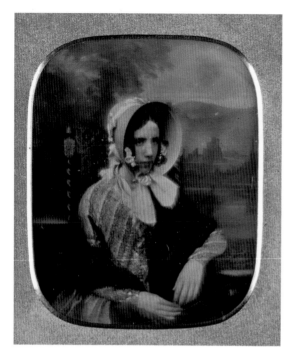

John William Lubbock, and as a postscript, added, 'I have received the
silver plate & am much obliged – Should you be writing to Paris for any
more, I will thank you to order a couple of dozen for me –'.[13] Lubbock wrote
to Talbot later that month to tell him that 24 silvered copper plates and
boxes for the daguerreotype, together with post and packing, cost 150
French francs, which he worked out at £5 18s 8d: 'I have no doubt that
you will get them very shortly.' Lubbock had bought an entire outfit, which
together with customs duty and a case came to 455 French francs, with
carriage extra.[14] Talbot appears to have obtained the development box
necessary for the process, although it is unclear whether he actually made
his own daguerreotypes [**Fig. 2.5**].

While complete daguerreotype kits varied, especially as the process
was improved, there is a similarity in the complete early outfits as they
would have been issued by Giroux in 1839, shortly after the working process
was made public. An outfit would have included Daguerre's manual, a
camera with lens and focussing back, a box for polished plates, an iodi-
sing box, a mercury box with spirit lamp and thermometer, an 'apparatus'
(as the plate holder was called), a box of the necessary chemistry, and
some hand tools like buffing sticks and a plate polishing vice.

One of the most striking attributes of the daguerreotype as a process,
particularly with a successful example, is the feeling of immediacy: a
21st-century viewer can feel connected to the subject, despite unfamiliar
clothes and unusual hair.[15] The viewer today can almost picture the sitter

turning and smiling or even speaking to the onlooker [**Fig. 2.6**]. Imagine the impact of such a contemporary image upon the Victorians, whose previous experience of personal representation was restricted to the miniature painting, the silhouette, or engravings after portraits. It is hardly surprising that anyone who could afford to obtain these small, personal objects, kept (except when being viewed) in a closed, velvet-lined leather case, gladly did so; and surprising numbers appear to have survived.

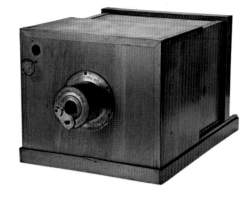

Until fairly recently it was a given that, apart from a few studios in fashionable London, and subsequently in a number of the larger cities, there were relatively few practising daguerreotypists, and correspondingly, not that many surviving products. Recent research has given this the lie, and it is apparent that despite inhibiting legal restrictions in its earliest years, the daguerreotype was taken up with great enthusiasm across the United Kingdom and beyond.[16]

Figs 2.5 (above and below)

Daguerreotype camera by Giroux (above); and a daguerreotype developing box (below). Both were owned by W. H. F. Talbot, 1839.

Customers for daguerreotype portraits had to be reasonably well-off, and in Britain tended to be drawn from the upper classes: the aristocracy,

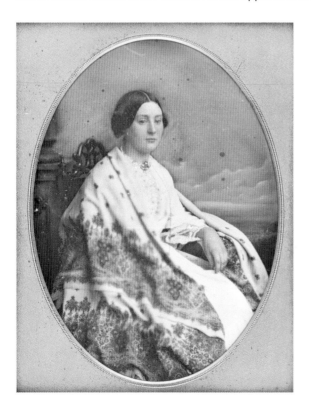

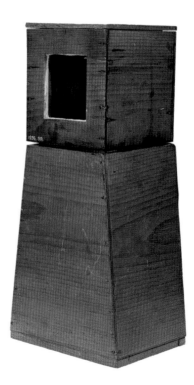

the gentry and aspiring middle classes. This was as true for Scotland as it was for the rest of the United Kingdom. In Edinburgh, as early as October 1839, James Howie senior (1791–1858), based at 64 Princes Street, was able to announce that he had 'succeeded in producing some beautiful specimens in the above NEW ART on SILVER, the First Public Exhibition of its kind in Scotland.'[17] Howie took daguerreotype portraits from 1841 and had taken street scenes by 1842.[18] The famous engraving by Joseph Ebsworth (1824–1908) of part of his panorama taken from the top of the Scott Monument, shows Howie's rooftop studio, four floors up from his Princes Street premises [**Fig. 2.7**].

This was described by a contemporary, who began by attributing the first professional photographic establishment in Edinburgh to Howie:

> Mr Howie's arrangements were at first of the simplest kind. His sitters had to climb three flights of stairs, and then by a kind of ladder reached a sky-light through which they got access to the roof of the house. The posing chair, with something in the shape of a head-rest fixed to its back, was placed against the gable of the adjoining building, and the operator used to take the sitter by the shoulders and press him down with the observation – "There! Now sit as still as death!" Of course, under such circumstances, with the sun shining brilliantly and the exposure counted by minutes, artistic portraiture was not to be expected; but Mr Howie did very well, notwithstanding, and gathered about him large numbers of those interested in the new art from all parts of the country.[19]

Howie's business centred around daguerreotype portraits, of which a number of, unfortunately anonymous, sitters, has survived [**Fig. 2.8**].

Amongst other daguerreotypists who set up in Edinburgh was the highly-regarded team of James Ross and John Thomson, who operated out of their Princes Street premises from 1847. The name of Ross & Thomson is now strongly associated with portrait daguerreotypes from Edinburgh, although contemporaries perhaps knew them better for their paper photography.[20] They were also well-known for their sensitive portrayal of children [**Fig. 2.9**]. One particularly solemn child is holding up a portrait of a man for the viewer to see: this is most likely her father, not long deceased. She was probably Scottish, but her identity, as well as that of her father, has vanished: what, one wonders, became of her?

In the United States, the daguerreotype became much more popular with the public than in England or indeed Scotland – it was not restricted by the patent to a few practitioners who had obtained a licence. Platt B. Babbitt (1822–79) became a well-known photographer, ensconced at a

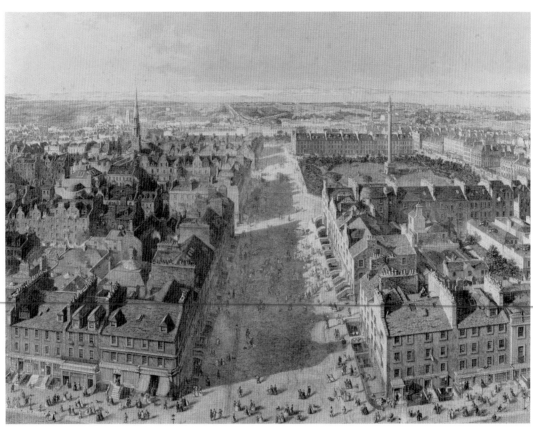

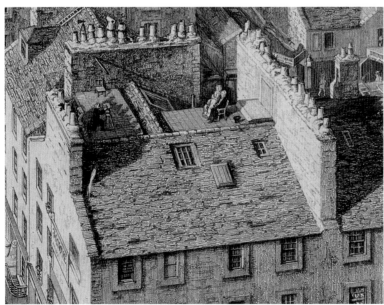

Fig. 2.7 (and detail)

J.W. Ebsworth, 'North View of Edinburgh, from the Upper Gallery of the Scott Monument ...', showing Howie's rooftop studio, September 1845.

Howarth-Loomes Collection at National Museums Scotland IL.2003.44.8.91

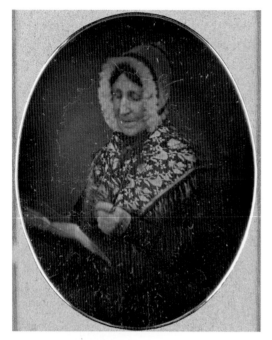

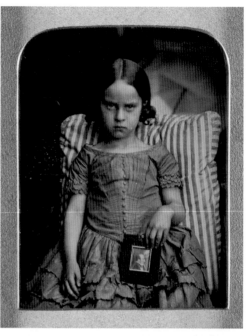

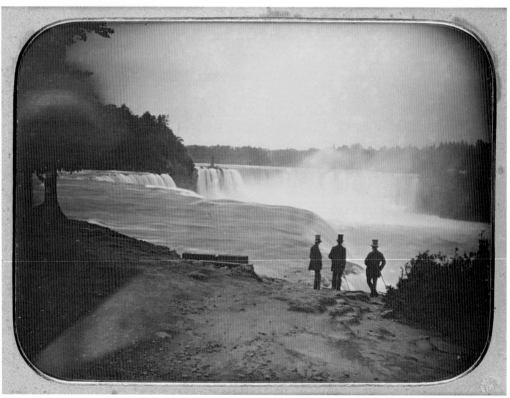

leading position beside the Niagara Falls, on the American side by 1853. He operated there almost exclusively until his death (by suicide) in 1879 [**Fig. 2.10**].[21]

The Glasgow photographer John Werge recounted how he had visited this famous studio in his travels around the United States between 1853 and 1855:

> I next went to Niagara Falls, where it was my good fortune to encounter two very different specimens of American character in the persons of Mr. Easterly and Mr. Babbitt, the former a visitor and the latter a resident Daguerrean, who held a monopoly from General Porter to Daguerreotype the Falls and visitors. He had a pavilion on the American side of the Falls, under which his camera was in position all day long, and when a group of visitors stood on the shore to survey the Falls from that point, he took the group – without their knowledge – and showed it to the visitors before they left. In almost every instance he sold the picture at a good price; the people were generally delighted to be taken at the Falls. I need hardly say that they were all taken instantaneously, and embraced a good general view, including the American Fall, Goat Island, the Horse Shoe Fall, and the Canadian shore. Many of these views I coloured for Mr. Babbitt, but there was always a beautiful green colour on the brink of the Horse Shoe Fall which I never could match. For many years I possessed one of Mr. Babbitt's Daguerreotype views, as well as others taken by Mr. Easterly and myself, but I had the misfortune to be deprived of them all by fire.[22]

The daguerreotype did not remain solely in the Western hemisphere: it travelled across the world with the makers of Empire. Rather unusually, two Muslim women, admittedly rulers of Indian states, and mother and daughter, were photographed by this method [**Fig. 2.11**]. These individuals were Sikander, Begum of Bhopal State in Central India (1818–68), and her daughter Shahjahan (1838–1901), also for a time Begum of Bhopal State, India, both by an unknown photographer, in about 1860.[23]

Fig. 2.8 (opposite left)

Ninth-plate daguerreotype of a seated woman in a shawl reading a book, signed 'HOWIE / PHOTOGRAPHER / 43 Princes Street / EDIN-BURGH'.

IL.2003.44.2.38

Fig. 2.9 (right)

Ninth-plate daguerreotype of a little girl on a striped cushion holding a framed portrait of a man (her dead father?), signed on the front of the case by Ross & Thomson of Edinburgh.

IL.2003.44.2.90

Fig. 2.10 (below)

Whole plate daguerreotype of the Niagara Falls with three men in top hats in foreground, stamped in corner of mount 'BABBITT / N.FALLS', c.1855.

IL.2003.44.2.83

All Howarth-Loomes Collection at National Museums Scotland

24

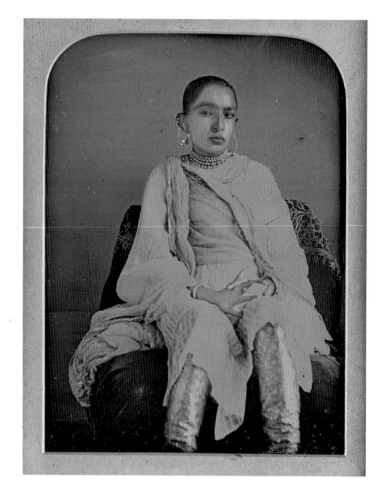

Fig. 2.11

Quarter-plate tinted daguer-
reotype by an unknown
photographer of Sikandar
(1818–68), Begum of Bhopal
State in Central India, *c*.1860.

National Museums Scotland
T.1961.13

Notes

1. Athenaeum 587, 26 January 1839: 69; John Hannavy (ed.) 2008. *Encyclopaedia of Nineteenth-Century Photography*, 2 vols (New York and Abingdon: Routledge), I: 92–3.
2. Richard D. Altick 1978. *The Shows of London* (Cambridge, MA, and London: Belknap Press of Harvard University Press), 163–72.
3. *Athenaeum* 587, 26 January 1839: 69.
4. *Athenaeum* 611, 13 July 1839: 523.
5. *Athenaeum* 617, 24 August 1839: .636–7.
6. R. Derek Wood, '"La Daguerréotypomanie" in *La Caricature*', <www.midley.co.uk/midley_pdfs/Caricature1839.pdf>
7. Not much else seems to be known about him biographically speaking: see <http://www.getty.edu/collection/artists/2225/theodore-maurisset-french-active-about-1839/>

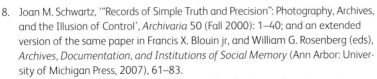

8. Joan M. Schwartz, '"Records of Simple Truth and Precision": Photography, Archives, and the Illusion of Control', *Archivaria* 50 (Fall 2000): 1–40; and an extended version of the same paper in Francis X. Blouin jr, and William G. Rosenberg (eds), *Archives, Documentation, and Institutions of Social Memory* (Ann Arbor: University of Michigan Press, 2007), 61–83.

9. A. Donné, 'Transformation en planches gravées des images tormées par le procédé Daguerre', *Comptes Rendu* 9 (1839): 485–6, delivered 2 October 1839; report 'Attempts at Engraving the Daguerréotype Pictures', in *Athenaeum* 624 (12 October 1839): 780–1.

10. Museum of the History of Science, Oxford, inv. no. 89963. It is thought that this daguerreotype may be one of two sent from Paris to John Ruskin as an Oxford student in late 1839 or early 1840, and thus one of the earliest daguerreotypes to be seen in the United Kingdom.

11. John Hannavy, 'Richard Beard's Scottish and Irish Patents, and the Development of the Daguerreotype in those Countries', *Daguerreian* Annual (2007): 88–101.

12. See <http://foxtalbot.dmu.ac.uk/letters/transcriptDocnum.php?docnum=5248> (Letter 5248, Andrew Ross to Talbot, 1839).

13. *Ibid.* <http://foxtalbot.dmu.ac.uk/letters/transcriptDocnum.php?docnum=3954> (Letter 3954, Talbot to John William Lubbock, 9 October 1839).

14. See <http://foxtalbot.dmu.ac.uk/letters/transcriptDocnum.php?docnum=3957> (Letter 3957, Lubbock to Talbot, 17 October 1839).

15. See Françoise Raynaud, 'The Daguerreotype as Object', in M. Daniel (ed.) 2003. *The Dawn of Photography: French Daguerreotypes 1839–1855* (New York and Newhaven: Metropolitan Museum of Art), 1.

16. Bernard Heathcote and Pauline Heathcote 2002. *A faithful likeness: the first photographic portrait studios in the British Isles, 1841 to 1855* (Lowdham: B. & P. Heathcote), 2.

17. *Scotsman*, 16 October 1839.

18. J. G. Tunny, 'Early Reminiscences of Photography,' *British Journal of Photography* 16 (12 November 1869): 546.

19. John Nicol, 'Reminiscences of Thomas Davidson, a weaver lad', *British Journal of Photography* 26 (22 August 1879), 399–401.

20. Examples of daguerreotypes by Ross and Thomson in public collections are to be found in the Scottish National Portrait Gallery, Edinburgh; National Museums Scotland, Edinburgh; National Media Museum, Bradford; Royal Collection, Windsor; University of Texas, Austin; Prentenkabinet Universiteit, Leiden; and the Rijksmuseum, Amsterdam.

21. Richard O. Titus, 'What's in a name? An inquiry into the identity theft of Platt Delascus Babbitt', Daguerrian Society Newsletter 20(2) (May–June 2008): 4–5.

22. John Werge 1890. *The evolution of photography with a chronological record of discoveries, inventions, etc, …* (London: Piper & Carter), 51.

23. See <http://apps.engr.utexas.edu/ethics/standards/bhopal/The%20Begums%20of%20Bhopal.pdf>

PART 3

FIRST IMAGES

Calotypes

… how charming it would be if it were possible to
cause these natural images to imprint themselves
durably, and remain fixed upon the paper!
And why should it not be possible? I asked myself.

*

W. H. F. Talbot, *The Pencil of Nature*
(London: Longman, Brown, Green and Longmans), 1844, page 4

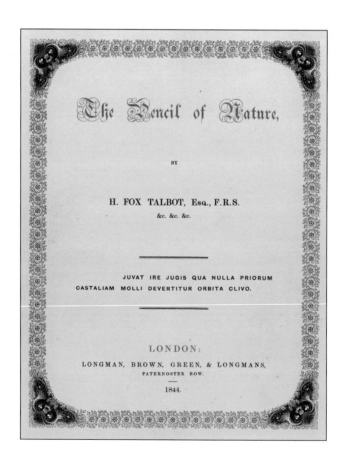

BEFORE photography, there was art. As we are all aware from our earliest years, some of our contemporaries can draw, and others cannot. Various mechanical drawing 'aids' have been developed over the centuries to assist those who lack artistic skills, especially those in the upper classes of society. In fact, this appears to be a peculiarly British phenomenon, associated with the custom of travelling abroad to extend a little educational polish during what became known as the 'Grand Tour', when young men were taken by their tutors around the sights of France, Germany and Italy.[1]

William Henry Fox Talbot (1800–77), inventor of the first successful positive/negative process, was only too aware of his deficiency. In 'a brief historical sketch of the invention of the art', in his first photographically-illustrated book, *The Pencil of Nature* [**Fig. 3.1**], in which he outlined a series of possible applications of his new discovery, Talbot explained that he fell into the latter category:

> One of the first days of the month of October 1833, I was amusing myself on the lovely shores of the Lake of Como, in Italy, taking sketches with Wollaston's Camera Lucida, or rather I should say, attempting to take them: but with the smallest possible amount of success. For when the eye was removed from the prism – in which all looked beautiful – I found that the faithless pencil had only left traces on the paper melancholy to behold.
>
> After various fruitless attempts, I laid aside the instrument and came to the conclusion, that its use required a previous knowledge of drawing, which unfortunately I did not possess.[2]

Talbot then thought of trying a camera obscura, which he had used before, but similarly with little success.

> This led me to reflect on the inimitable beauty of the pictures of nature's painting which the glass lens of the Camera throws upon the paper in its focus – fairy pictures, creations of a moment, and destined as rapidly to fade away.
>
> It was during these thoughts that the idea occurred to me … how

Pages 26–27

Camera, printing frame, iron and balance, used by W. H. F. Talbot in the calotype process, 1840s.

National Museums Scotland T.1936.21, 22, 95 and 96

Fig. 3.1 (opposite)

Title page of *The Pencil of Nature* by W. H. F. Talbot, 1844–46.

National Museums Scotland T.1937.92

charming it would be if it were possible to cause these natural images to imprint themselves durably, and remain fixed upon the paper! And why should it not be possible? I asked myself.[3]

This is the moment when Talbot resolved to try to obtain natural images without human art or intervention.

Talbot was an English landowner, scholar and scientist. He had the leisure-time and wealth to pursue his scientific interests. He returned to England in early 1834 and began experimenting, as he tells his readers, with silver salts. Initially, he was able to obtain what we would term 'negative' images of lace, or leaves, exposed to sunlight against paper previously dipped in a silver solution; but the sensitised paper placed in a camera obscura and directed towards views or architecture produced only vague outlines and a disappointing lack of detail. It also seemed to take a considerable amount of time. But in due course, he was able to capture images.

He produced his first successful negative, fixed with common salt, in the summer of 1835, after years of experimenting in private. Spurred into action by the announcement of Daguerre's discovery in the press in January 1839, Talbot rapidly put forward his process of 'photogenic drawing' for publication and exhibition in February. After further work, he discovered the possibility of developing the invisible latent image (formed during much shorter exposure times), and patented his improved process in the February of 1841. In due course, numerous positive images could be obtained from Talbot's single negative, and this process – the calotype – became the ancestor of nearly all photographic methods using chemistry, until the emergence of digital photography during the late 1990s.

Talbot used a number of cameras, some dating from about 1840 [**Fig. 3.2**]. The calotype negative was made by projecting an image through a lens on to a piece of chemically sensitized paper fixed inside the camera. When developed, this produced a negative image. This was then placed in the printing frame with another piece of sensitized paper beneath it and exposed to sunlight. A positive image was produced which had to be fixed with chemicals. Talbot used his balance for

Fig. 3.2

Camera, printing frame, iron and balance, used by W. H. F. Talbot in the calotype process, 1840s.

National Museums Scotland
T.1936.21, 22, 95 and 96

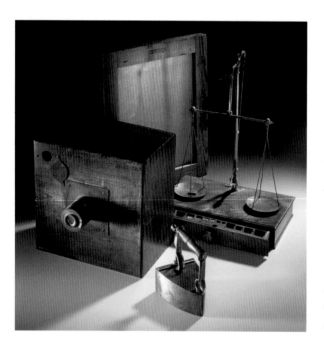

weighing chemicals and an ordinary domestic iron to apply wax to his negatives, making them more transparent and reducing the printing time.

His ambitions for the applications of photography included the dissemination of information through illustrated publications. He set up an establishment at Reading in 1844 especially to produce *The Pencil of Nature* and other calotype works. This was the first book to be illustrated with photographs. Produced in six parts, it demonstrates that Talbot selected his subjects carefully. He understood that readers would be unfamiliar with photography, and he wished to impress them with the detail achieved by the medium [**Fig. 3.3**]. He also wanted to show that photographs could do things that other forms of illustration could not, such as duplicating fragile ancient documents for antiquarians; recording items for householders against theft; or enlarging or reducing copies of engravings. The first part was made in 285 copies and, with encouraging sales figures, 150 were produced of the second part. It seems probable that 150 copies of each of the final parts were manufactured. A very few of these complete volumes still exist today. Some of the images are works of art in their own right [**Fig. 3.4**].

Talbot patented his invention in England, which meant that for commercial use, the photographer was obliged to purchase a licence. However, the public found that the quality of the image – in which a paper negative was reversed on to a paper print, and all the fibres made the image more impressionistic than that of the rival daguerreotype method – was not

Fig. 3.3

'The Open Door', plate VI from W. H .F. Talbot's *The Pencil of Nature*, unmounted salt print from a calotype negative.

National Museums Scotland T.1937.92.6.2

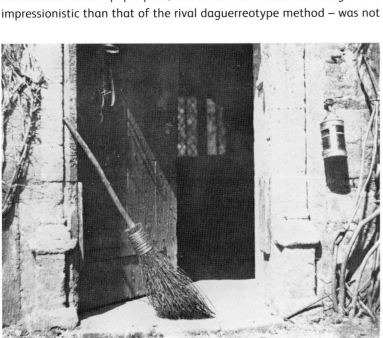

Fig. 3.4 (right)

'The Ladder', plate XIV from W. H .F. Talbot's *Pencil of Nature*, unmounted salt print from a calotype negative.

National Museums Scotland
T.1937.92.14

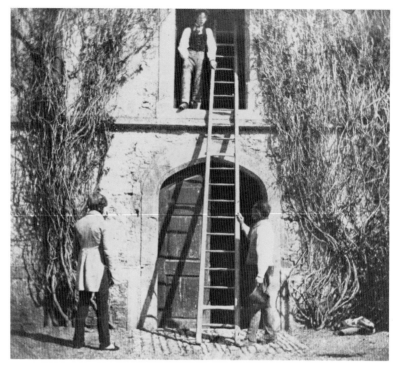

Figs 3.5 (below)

Two pages from Dr John Adamson's photograph album, showing two salt print (positives) on the left-hand page made from calotype negatives on the right-hand page.

National Museums Scotland
T.1942.1.1.16 and 17

from the opposite negative

a negative portrait

a positive from the opposite negative

a negative

what they wanted [**Fig. 3.5**]. Talbot was in touch, through the recently-invented penny post, with the scientist Sir David Brewster (1781–1868) at St Andrews, where a circle of people, including the Adamson brothers, Dr John and Robert, taught themselves his process [**Fig. 3.6**]. This 'calotype process' became the preferred method of photography for amateurs, mostly wealthy men; although the images produced by the Edinburgh partnership of Hill and Adamson are regarded as superb.

Robert Adamson (1821–48) went to Edinburgh in early May 1843 to pursue photography commercially from Rock House on Calton Hill [**Fig. 3.7**]. Almost immediately, there was a schism in the Church of Scotland, and the artist D. O. Hill (1802–70) [**Fig. 3.8**] was inspired to make a great painting of the occasion. Hill was introduced to Adamson by Sir David Brewster, and they began making calotype portraits of various ministers for the picture. Soon, beguiled by the results, the pair began to take photographs of Newhaven fisherfolk, historic places in and around Edinburgh, and portraits of interesting people.

Dr John Adamson's album contains a number of images taken by his younger brother Robert Adamson (1821–48) while in partnership with the Edinburgh artist, David Octavius Hill (1802–70). The pair travelled to St

Fig. 3.6

Page showing very early salt prints made in St Andrews, by the Adamson brothers (Dr John and Robert) in summer 1842.

National Museums Scotland T.1942.1.2.87

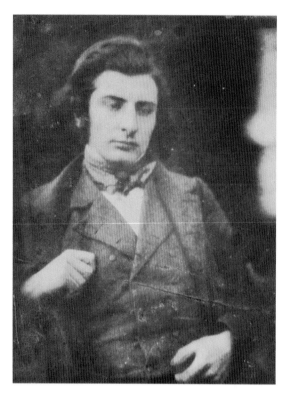

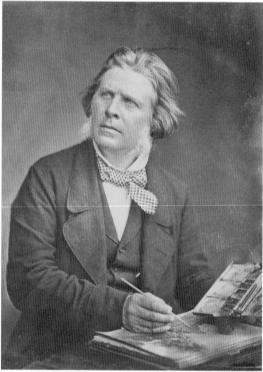

Fig. 3.7 (left)

Robert Adamson, by Dr John Adamson, salt print from a calotype negative, 1844.

National Museums Scotland
T.1942.1.1.93

Fig. 3.8 (right)

D. O. Hill, by Dr John Adamson, albumen print from a wet collodion negative, 1855.

National Museums Scotland
T.1942.1.1.182

Andrews, where they photographed the ruins and some of the people [**Fig. 3.9**]. As the artist John Harden wrote on seeing calotypes for the first time in November 1843:

> The pictures produced are as Rembrandt's but improved, so like his style & the oldest & finest masters that doubtless a great progress in Portrait painting & effect must be the consequence.[4]

In 1844, Hill and Adamson bought from Thomas Davidson a large-format camera, and took it with them to the annual meeting in York of the British Association for the Advancement of Science in summer 1844. Either on the way, or on the return journey, they stopped at Durham to photograph the great Norman cathedral there [**Fig. 3.10**]. Miss Elizabeth Rigby, one of photography's early critics, noted in her diary for 19 December 1844: 'To Mr Hill's to see his wonderful calotypes – one of Durham most exquisite'.[5]

Together, Hill and Adamson made about 3000 images between 1843 and January 1848, the time of Adamson's premature death. In 1851, Hill presented an album of 110 examples of their work to the Society of Antiquaries of Scotland. Hill chose subjects that would have most interested

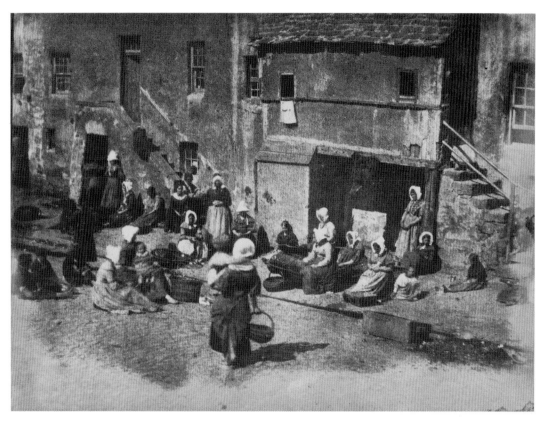

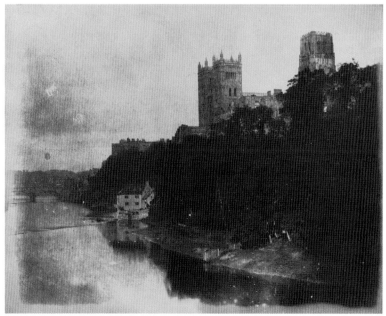

Fig. 3.9 (above)

Fishergate, St Andrews, by
D. O. Hill and Robert Adamson,
salt print from calotype
negative, 1843–48.

National Museums Scotland
T.1942.1.1.53.2

Fig. 3.10 (left)

Durham Cathedral, salt print
from a calotype negative, by
D. O. Hill and Robert Adamson,
1844.

National Museums Scotland
T.1977.4.2

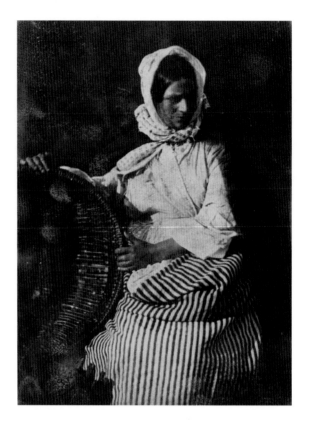

Fellows of the Society – historical ruins, famous people and antiquarian subjects. One image shows Mrs Elizabeth (Johnstone) Hall, a Newhaven fishwife, famous for her beauty and self-confidence [**Fig. 3.11**]. The Newhaven fisherfolk were considered to be an autonomous and self-supporting community, admirable for their independence.[6]

James F. Montgomery (1818–97), an advocate, also presented an album of salt prints which had been made by the calotype process, to the Society of Antiquaries of Scotland in 1851. These appear to have been made by a group of mainly lawyers who formed the world's earliest photographic society: the Edinburgh Calotype Club. The members 'met at each other's houses, had a friendly meal together, exhibited their productions, and discussed new experiments and their results'.[7] Two other albums of the Club's work survive.[8] The quality of their images is sadly nowhere near as good as those produced by Hill and Adamson. One of the images shows Newhaven fisherfolk, looking ill-at-ease in comparison with those photographed by Hill and Adamson, demonstrating that there was more to their photographs than just understanding the chemicals and technology. Taking good photographs has always been difficult [**Fig. 3.12**].

Notes

1. See Carol P. Richardson and Graham Smith (eds) 2001. *Britannia, Italia, Germania: taste and travel in the nineteenth century* (Edinburgh: VARIE).
2. William Henry Fox Talbot 1844–46. *The Pencil of Nature* (London: Longman, Brown, Green and Longmans), 3.
3. *Ibid.* 4.
4. Quoted by Sara Stevenson 2002. *The Personal Art of D. O. Hill* (New Haven and London: The Paul Mellon Centre for Studies in British Art by Yale University Press), 35.
5. Quoted by David Bruce 1973. *Sun Pictures: The Hill-Adamson Calotypes* (London: Studio Vista), 161.
6. Sara Stevenson 1991. *Hill & Adamson's 'The fishermen and women of the Firth of Forth'* (Edinburgh: National Galleries of Scotland).
7. John Miller Gray 1928. *Calotypes by D. O. Hill and Robert Adamson Selected from his Collection by Andrew Elliott* (Edinburgh: privately published). For a discussion of the Club's history, see Roddy Simpson 2012. *The Photography of Victorian Scotland* (Edinburgh: Edinburgh University Press), 47–52.
8. In the National Library of Scotland, and Edinburgh City Library. See <http://digital.nls.uk/pencilsoflight/search.cfm>

37

Fig. 3.12

Volume 2, page 13, Newhaven Fishwives, unattributed photographer.

National Museums Scotland
D.2014.3.13

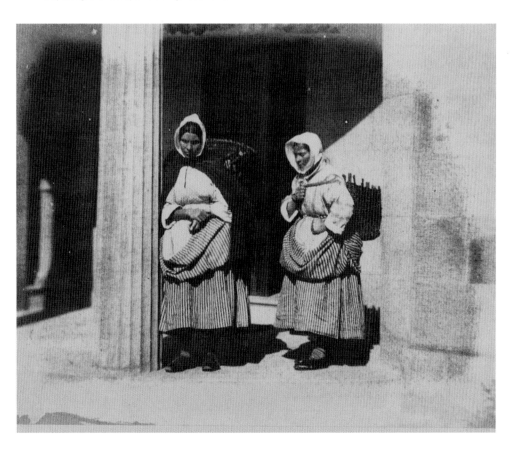

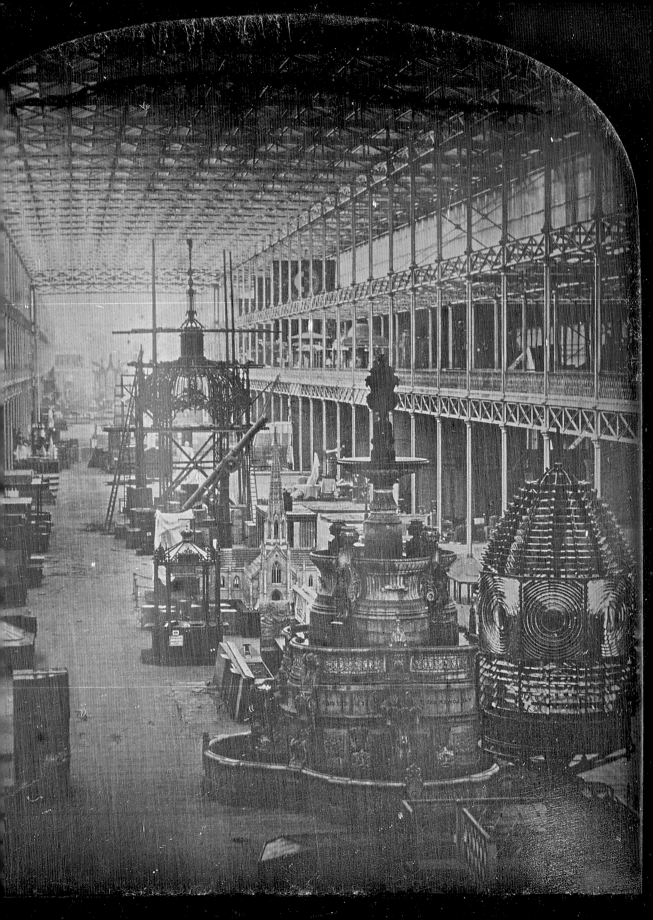

PART 4

TREASURES

1851 – A Year of
Photographic Developments

Mrs Archer says in her letter to me: 'Tomorrow … we shall consign my dear husband to the grave …. His health failing, he could not help regretting the time he had spent in mere experiments, instead of making exertions to provide for the wants of his family.'

*

J. J. E. Mayall in the *Journal of the Photographic Society*, 21 May 1857

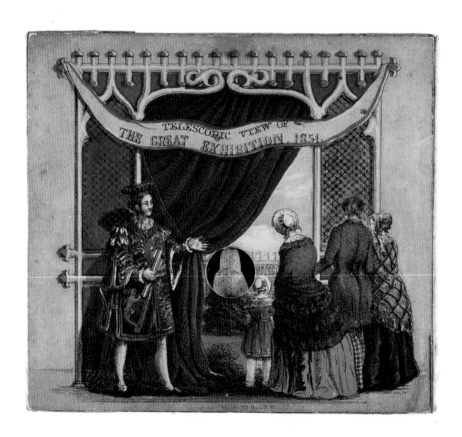

IN 1851 a number of milestones occurred in photography, including the announcement of Frederick Scott Archer's wet collodion process, and the introduction of Sir David Brewster's lenticular stereoscope. For the public it was the year of the tremendously successful Great Exhibition, held from May to November in the specially-built temporary Crystal Palace, in Hyde Park, London. This was an international sensation that displayed works of industry from all around the world, the first of the great international exhibitions of the second half of the 19th century. Organised by Prince Albert and a committee of politicians, scientists and administrators, the exhibition was an attempt to showcase the best of British art and industry to the world. Artisans were encouraged to visit in special trains on reduced entry days and six million people visited the Great Exhibition during the six months it was open.

The building itself was an extraordinary confection of prefabricated steel and glass; souvenirs of this unforgettable experience were sold to visitors, including the concertina peepshow opposite [**Fig. 4.1**]. The ten linked lithographic prints that make up the peepshow are joined by linen hinges to create a perspective view inside the Crystal Palace, the vast glass and iron structure designed by Joseph Paxton to house the exhibition. With its depiction of attendees lining up outside the Crystal Palace, the front plate of Lane's 'Telescopic View of the Great Industrial Exhibition' plays on the idea of the peepshow as souvenir. Looking through the lens gives a three-dimensional impression of the occasion. There were other mementos too, among them stereo daguerreotypes of the inside of the Crystal Palace.

Stereoscopic vision had been at the forefront of experimental science since Sir Charles Wheatstone demonstrated it at a meeting of the British Association for the Advancement of Science in 1838. His idea was based on the principle that a pair of drawings of a single object made from slightly different points of view (left and right) coalesced into a single 3-D representation when seen through a specially designed viewer he called a stereoscope. One of Wheatstone's chief adversaries was Sir David Brewster (1781–1868), whose numerous scientific papers on optics, the nature of light and the physiology of human vision placed him at the very forefront of his field. During the course of these investigations Brewster found

Pages 38–39

A stereoscopic daguerreotype of the interior of the Crystal Palace showing the British Department, probably by T. R. Williams, 1851.

Howarth-Loomes Collection at National Museums Scotland IL.2003.44.2.296

Fig. 4.1 (opposite)

'[Lane's] Telescopic View of the Great Exhibition, 1851' peepshow.

Howarth-Loomes Collection at National Museums Scotland IL.2003.44.10.77

Wheatstone's viewer to be 'of little service, and ill-fitted, not only for popular use, but for the application of the instrument to various useful purposes'. After experimenting with alternative designs he came up with an altogether simpler viewer that could easily be held in the hand: he called it a lenticular stereoscope [**Fig. 4.2**]. Disheartened by an indifferent reception in Britain, Brewster offered his design to eminent Parisian instrument maker, Jules Duboscq (1817–86), in 1849, who immediately saw its potential. In the words of one commentator, the Abbé Moigno, Duboscq created a viewer of such beauty that it attracted 'a spontaneous and unanimous cry of admiration' (Brewster's translation) from all who saw it. In fact, the Brewster stereoscope appeared in time to be used with the daguerreotype, and with this process it became extremely popular.

Some of the earliest stereo daguerreotypes, unusual survivals, show different views inside the Great Exhibition in London's Hyde Park in late 1851. One shows the famous elm tree in the north aisle, and is stamped on the back with the monogram 'DS' for the Parisian firm of Duboscq-Soleil [**Fig 4.3 a**]. Two others show views to the east and west, with the nave filled with exhibits: they may have been taken by T. R. Williams (1824–71), a photographer who went on to be employed by the London Stereoscopic Company, before working for himself [**Figs 4.3 b and c**].[1]

An outstanding inventor, Duboscq married into a family business that specialised in optical instrument-making, and he was particularly interested in optical effects through lenses. Duboscq provided stereo daguerreotypes for use with his Brewster stereoscopes, as well as lithographs, which could be produced cheaply and rapidly to fulfil demand. Brewster wrote that, having seen the prototype instrument:

M. Duboscq immediately began to make the new stereoscope for sale, and executed a series of the most beautiful binocular daguerreotypes of living individuals, statues, bouquets of flowers, and objects of Natural History, which thousands of individuals flocked to examine with the new instrument [**Figs 4.4**].[2]

Much of this material reflected the scientific interests of mid-century Paris, and the circles in which Duboscq moved. These were sold by a variety of shops in both London and Paris.

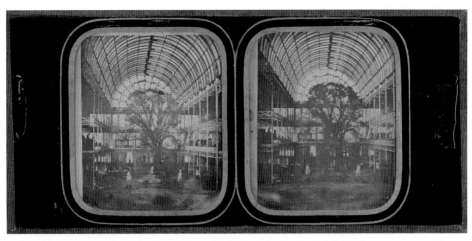

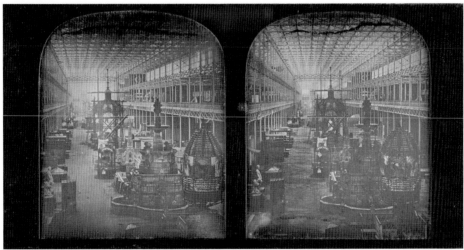

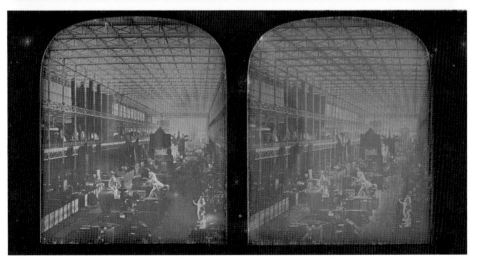

43

Figs 4.4 (right and middle)

Still life, snake in a tree, stereo daguerreotype by J. Duboscq; and still life, snake in a tree, stereo lithograph, from a daguerreotype by J. Duboscq.

Howarth-Loomes Collection at National Museums Scotland IL.2003.44.2.312 and IL.2003.44.6.5.479

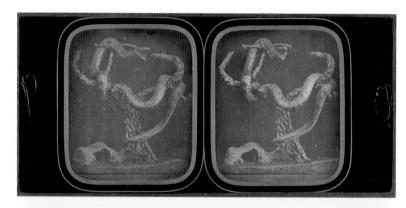

Fig. 4.5 (below left)

Brewster-pattern hand-held wooden stereoscope, *c.*1855.

Howarth-Loomes Collection at National Museums Scotland IL.2003.44.10.1

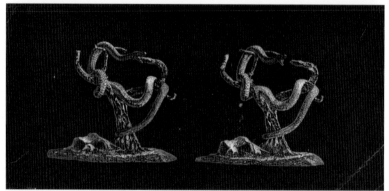

Fig. 4.6 (below right))

Brewster-pattern hand-held stereoscope with Japanese lacquer-work decorated body.

Howarth-Loomes Collection at National Museums Scotland IL.2003.44.10.22

Brewster stereoviewers at this date appear to have been fairly simple in their construction [**Fig. 4.5**], though patterned examples would have been more expensive, but suitably gracious for any middle-class drawing-room [**Fig. 4.6**]. These were made in a standard size to fit stereo daguerreotypes. They became extremely popular in the 1850s, though much more expensive to create – and therefore to buy – than the slightly later albumen prints produced by the wet collodion process.

Stereoscopic daguerreotypes were capable of a sharpness of definition well-suited to three-dimensional viewing, and many London photographers, including T. R. Williams, Antoine Claudet, J. J. E. Mayall and W. Kilburn, produced them. From a commercial viewpoint, they possessed serious disadvantages. Each slide required two separate exposures, or two cameras side by side; and if several identical sides were required, the subject had to be re-photographed, or the originals copied in the photographer's studio. Large-scale production was impossible. Prices for slides ranged from 8s 6d to 12s 6d (equivalent to between about £40–60 today), very expensive at the time. The subjects were typically portraits, usually commissioned by the sitter, or examples of sculpture and views of exhibitions. Outdoors scenes, even those outwith the photographer's studio, were rare.

The view [**Fig. 4.7**] inside the Museum of the Royal College of Surgeons, London was taken in 1852 by a photographer named Timothy Le Beau (1798–1868); it shows in the foreground the cast of an African by Sartini, and behind this the skeleton of the elephant Chunee, the giraffe from John Hunter's collection (without its head) and an Irish elk.[3] Other examples are known. However, another view, this time outdoors, appears to be the sole survival [**Fig. 4.8**]. It shows the demolition of I. K. Brunel's original

Fig. 4.7

'View of the Museum of the Royal College of Surgeons, London', by Timothy Le Beau (1798–1868), 1852, stereo daguerreotype.

Howarth-Loomes Collection at National Museums Scotland IL.2003.44.2.229

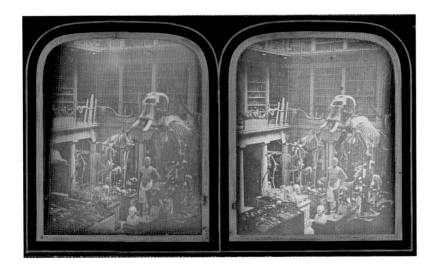

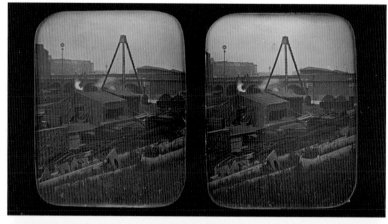

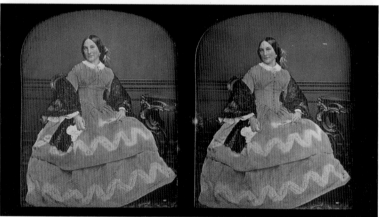

Fig. 4.8 (above)

Stereo daguerreotype of the building of the extension to Paddington Station, by an unknown photographer, c.1852.

Howarth-Loomes Collection at National Museums Scotland IL.2003.44.2.270

Fig. 4.9 (right)

Portrait of woman wearing a purple dress, stereoscopic daguerreotype by T. R. Williams, 1850s.

Howarth-Loomes Collection at National Museums Scotland IL.2003.44.2.326

Paddington Station, built in 1838 as a provisional London terminus for the Great Western Railway, by an unknown photographer, c.1852 and is a stereo daguerreotype. The view shows large iron columns, with end flanges, lying on the ground in the foreground, and further ironware beyond. Only five figures can be seen, gazing over the bridge – steam from an invisible locomotive swirls out from the arches. A third [**Fig. 4.9**] – this time, a studio photograph, included because it is so beautiful – shows a stereo daguerreotype portrait of an unidentified woman in a pale purple crinoline. This is by T. R. Williams of London and is dated to the 1850s.

Frederick Scott Archer (1813–57) was a London-based sculptor who found calotype photography useful as a way of capturing images of his sculptures. However, he became dissatisfied with the poor definition and contrast of the calotype and the long exposures needed. After considerable experimentation, he invented the wet collodion process in 1848. He published his method in *The Chemist* in March 1851. By doing so without

patenting it first, Archer gave it as a gift to the world, and died impoverished, making very little money from his method. His family were left destitute, although photographic societies raised money on their behalf.

Archer's wet collodion process combined the best elements of the daguerreotype and calotype processes. Though it was messy, smelly and awkward, it was much faster and much cheaper. The camera remained essentially the same – a box with a lens, with another smaller box sliding within to vary the focus [**Fig. 4.10**]. A glass plate is coated with the wet collodion solution (pyroxylin in alcohol and ether) containing light-sensitive silver salts and exposed whilst the plate is still wet. Photographs have to be taken within 15 minutes of coating the plate, so a portable dark room is needed; the exposure time is less than required for daguerreotypes and calotypes, making outdoor photography easier. A sharp glass negative image is created that captures microscopic detail and positive copies can be made from this, usually of albumen prints on paper [**Figs 4.11**]. Ambrotypes (or wet collodion positives) were formed by painting the back of the glass negative image with black paint, or placing a piece of black card there. It could be put into a protective case, resembling that of the daguerreotype, with which it is sometimes confused [**Fig. 4.12**].

The faster and cheaper chemicals used in the wet collodion process allowed much more informal portraits to be taken outdoors, on the beach and even in passing: animals, especially horses, which formed such an enormous part of Victorian life, could be photographed without ruining the picture through movement [**Fig. 4.13**]. Nonetheless, older people were unsure of what to expect in a photographer's studio and often viewed the experience with some alarm, which is apparent in **Fig. 4.14**. Often people

Fig. 4.10

Wet plate camera made by Andrew Ross of London, with ground glass screen, and double dark slide for negatives, c.1855.

National Museums Scotland
T.1967.173

Figs 4.11

Glass plate negative made by wet collodion process – image of a ruined abbey, unknown photographer, after 1851 to late 1880s, with albumen print from the same negative.

National Museums Scotland
T.2014.6.1 and 2

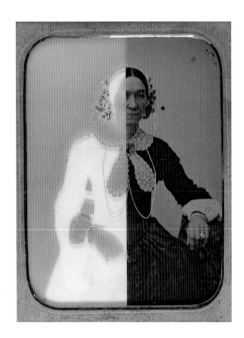

posed in the studio, or outside for a less formal portrait, with something to indicate their standing in life or their interests (such as music or literature). Some indicators or studio props have lost currency today; others – such as signs of mourning – can be easily interpreted [4.15].

Most major industrialised countries experienced the enormous popularity of photography and its use in jewellery, though vogue for it was greatest in England, France, Germany and the United States. Queen Victoria increased worldwide acceptance of the taste by wearing and collecting a variety of photo-jewellery – making a fashion statement that many embraced. Wealthy consumers in every Western country had long enjoyed the painted portrait miniature. Daguerreotype jewellery offered almost all the same attributes, and additionally an exact mirror image of a loved one, in a small, jewel-like, wearable object of charm and sometimes great beauty [Fig. 4.16]. Although cheaper to produce and purchase, ambrotype jewellery could also be extremely attractive. Often this sort of very personal adornment was in memory of the person whose portrait was used.

Fig. 4.12

Sixth-plate tinted ambrotype, with half backing paper removed to demonstrate the effect of a dark background under the bleached negative, c.1855.

Howarth-Loomes Collection at National Museums Scotland IL.2003.44.1.13

Fig. 4.13

Quarter-plate ambrotype, portrait of a grey horse harnessed but with no saddle and a man holding its bridle, taken by a photographer of the London School of Photography, based at Newgate Street and Regent Circus, London, 1858– 60. It has been suggested that this photograph was taken in Scotland from recognisable features of the stable-yard.

Howarth-Loomes Collection at National Museums Scotland IL.2003.44.1.147

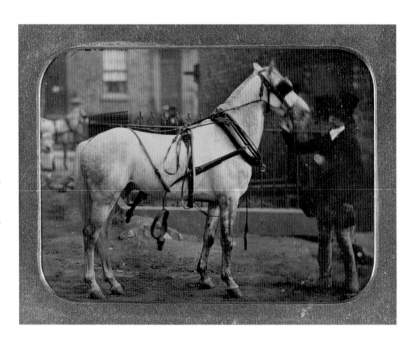

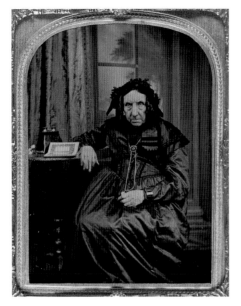
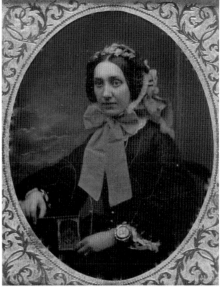

Fig. 4.14 (above left)

Sixth-plate ambrotype of an elderly woman with a Brewster stereoscope, unknown photographer, 1850s–60s.

IL.2003.44.1.9

Fig. 4.15 (above right)

Eighth-plate tinted ambrotype, of young woman in mourning, holding a daguerreotype and wearing daguerreotype bracelet, by J. Douglas, Artist, 145 Sauchiehall Street, Glasgow, c.1856.

IL.2003.44.1.19

Fig. 4.16 (below)

Oval brooch with daguerreotype of a man. The back has his woven hair. Engraved 'W. Bishop, born March 30 1812, married June 18 1844, died June 1 1854 aged 42 years'.

IL.2003.44.2.331

All images Howarth-Loomes Collection at National Museums Scotland

Notes

1. Bonhams, Chelsea, *An Important Collection of T. R. Williams Daguerreotypes*, 6 July 1995, lots 18, 28–31. Examples of these views are identified on the Victoria and Albert Museum's website as being by T. R. Williams, inv. nos 1685–1939 and 1682–1939.
2. David Brewster 1856. *The Stereoscope: its history, theory, and construction* (London: John Murray), 30.
3. There is an example at the Victoria and Albert Museum, inv. no. 37-1972. The example at the Royal College of Surgeons, inv. no. RCSSC/P 3238, dates the image to 1852, and ascribes it to Timothy Le Beau: <http://surgicat.rcseng.ac.uk/Details/collect/48221> And for Le Beau, see Keith I. P. Adamson, 'More early studios, Part 2', *Photographic Journal* 128 (1988): 307; <http://www.photolondon.org.uk/pages/details.asp?pid=4655>

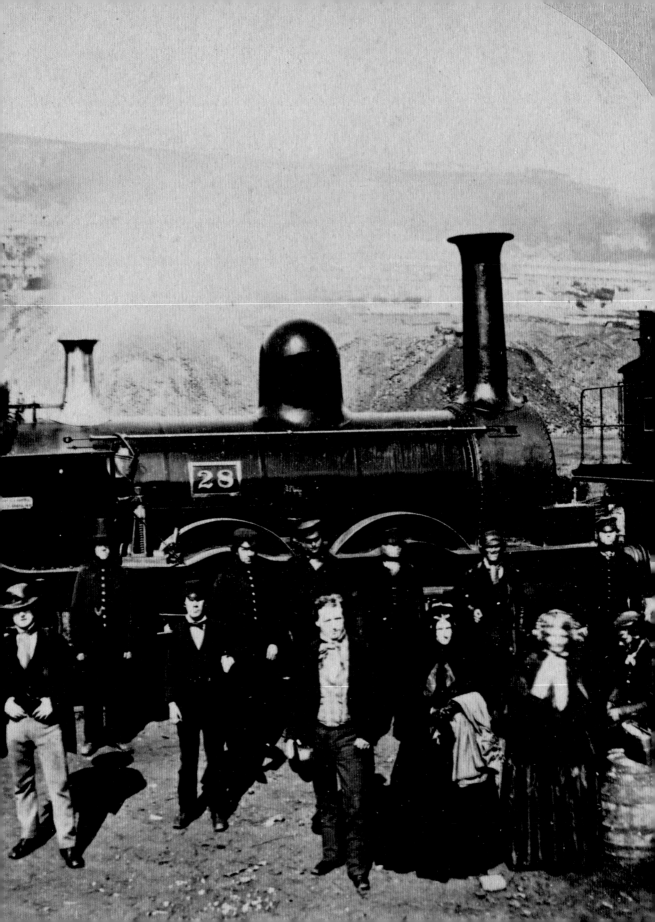

PART 5

EXPLOSION OF PHOTOGRAPHY

Studio Photography

WITH Archer's invention, there was a veritable 'explosion' of photography: the Victorians could not get enough of this truthful representation of reality. In 1851, there were about a dozen studios in London; by 1866, this number had increased to 284. Studio photography could be expensive, but as photography became respectable and photographers settled in premises in the fashionable parts of town, so patrons were prepared to visit and sit for their portraits. The most popular form of photography during the 19th century was undoubtedly the carte-de-visite, which emanated from the studio. The craze of collecting stereo photographs (or stereographs) of every type, was superseded by the Victorian enthusiasm for the carte-de-visite, which amounted to a passion.

Formal photographs were taken of wealthier customers, who would find themselves in a well-lit studio resembling a greenhouse (daylight was the cheapest form of lighting mid-century), seated in front of a large plate camera [**Fig. 5.1**], usually with a head-rest to prevent the sitter's head from wobbling during the exposure [**Fig. 5.2**]. Other devices were used in the studio to help the sitter feel that the experience had been worthwhile (and possibly worth return visits). This included the retouching desk, at which dedicated female assistants could carefully brush out double chins, wrinkles and other perceived blemishes on the negative before positive prints were made; or even carefully colour the eventual prints [**Fig. 5.3**].

Even so, amateurs continued to take photographs using the wet collodion process, and among those that are highlighted here are Dr John Adamson (1809–70), who continued to take photographs in St Andrews after his younger brother Robert moved to Edinburgh in 1843 [**Fig. 5.4**]. Adamson took some much-admired portraits in later life – his portrait entitled 'Old Lady Reading', is of his mother, Rachel Adamson, née Melville. This photograph was shown at the Photographic Society of Scotland's 1864 exhibition. Adamson's protégé Thomas Rodger (1832–83) built a studio for his own commercial use, and as the doctor's time was taken up increasingly with his burgeoning medical practice, Rodger allowed his former employer to use the premises for his hobby. Adamson wrote to the Photographic Society of Scotland in November 1861:

Pages 50–51

'Arrival of Passenger Train', sold by the London Stereoscopic Company, 1854–56, stereo albumen prints from a wet collodion negative.

Howarth-Loomes Collection at National Museums Scotland IL.2003.44.6.16.141

Fig. 5.1 (opposite above)

Whole plate camera, by Tunny of Edinburgh, and tripod table of wood for large plate cameras, with height and tilt angle adjustable by handles, c.1860.

National Museums Scotland T.1953.X.13 and T.1970.X.1

Fig. 5.2 (opposite right)

Head rest for photographic studio use, by Harvey Reynolds, Leeds, c.1860.

National Museums Scotland T.1983.189

Fig. 5.3 (opposite left)

Variable-size plate photographic retouching desk, by an unknown maker, c.1860.

National Museums Scotland T.1985.19

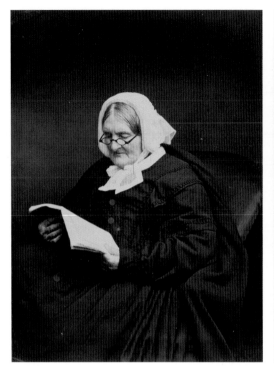

Fig. 5.4

'Old Lady Reading, aged 84', by Dr John Adamson, 1864, albumen print from a wet collodion negative.

National Museums Scotland T.1942.1.1.259

Fig. 5.5

'Alfred Tennyson', by Julia Margaret Cameron, 3 June 1870, albumen print from a wet collodion negative.

Howarth-Loomes Collection at National Museums Scotland IL.2003.44.9.68

I wish very much that the large heads should be exhibited to advantage as I entertain a hope that they may in some small degree help to turn public taste from the small 'carte-de-visite' pictures so fashionable at present and in which I think the photographic art has been progressing backwards – to portraits of a larger size – and a more ambitious aim in the direction of the painter's field of operation.[1]

Another renowned amateur was Mrs Julia Margaret Cameron, *née* Pattle (1815–79), who took up photography at the age of forty-eight. She was born in India, married a judge, who also owned extensive coffee plantations, and they retired from Ceylon to England in 1848. She became part of an intellectually-active artistic circle in London. In 1860 she visited the Poet Laureate, Alfred, Lord Tennyson (1809–92) on the Isle of Wight: Mrs Cameron immediately bought the next door property. As a Christmas present in 1863, while her husband was in Ceylon, her daughter and son-in-law gave her a camera, saying: 'It may amuse you, Mother, to try to photograph during your solitude at Freshwater.'[2] She duly proceeded to photograph writers, artists, scientists, as well as visitors and servants, who came her way. Many of her prints were sold through the London art dealers, P. & D. Colnaghi. It has been suggested that she took up photography for

commercial reasons, although it is unlikely she ever made it profitable. She took many photographs of the Poet Laureate [**Fig. 5.5**]. A critic in 1870 wrote that:

> Amateurs are not as a rule successful in portrait-taking, but we must make an exception in favour of a lady, Mrs Cameron, whose life-size portraits … are taken with the large lens, and, without the appearance of art, are yet most artistic portraits. The head of Alfred Tennyson, with its flowing locks, shows us the power of photography in large – if we may so speak. Mrs Cameron has a fine sense of light and shade, and the heads she has taken remind us of the noble pencilling of Correggio, so grandly are the masses of light and shade disposed.[3]

This contrasts with Tennyson's crisp remark: 'I can't be anonymous by reason of your confounded photographs'.[4]

The carte-de-visite

The most popular form of 19th-century photography was undoubtedly the carte-de-visite. André Adolphe Eugène Disdéri (1819–89) was a young aspiring photographer who was based in Paris in the early 1850s. In 1854, he patented his carte-de-visite, a size of photograph based on the traditional visiting card (although slightly larger), and relatively inexpensive [**Fig. 5.6**]. Disdéri realised that he could reduce his costs by taking several smaller negatives on a single plate, and introduced the fashion for the smaller – and cheaper – carte commercially. He was also responsible for its popularisation. The craze crossed the Channel in about 1857. Unlike earlier forms of photography, it reached almost every level of society except the destitute.

Most of the equipment necessary to take cartes-de-visite was already available in the photographer's studio. These included a camera – which could be adapted with a special sliding plate-holder taking several of the carte-sized images on one plate [**Fig. 5.7**]. Otherwise the props, including head-rests, backdrops and studio sets, remained essentially the same. There is considerable information in an unsigned, probably French, stereograph, showing posed models apparently producing cartes in a single image [**Fig.

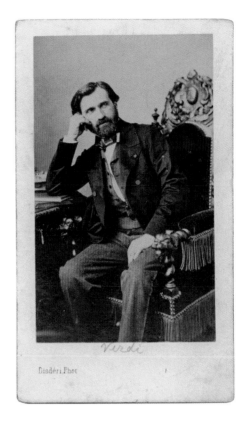

Fig. 5.6

Portrait of Giuseppi Verdi (1813–1901), the Italian composer, by A. A. E. Disdéri, 8 Boulevard des Italiens, Paris, 1860s, carte-de-visite.

Howarth-Loomes Collection at National Museums Scotland IL.2003.44.4.55

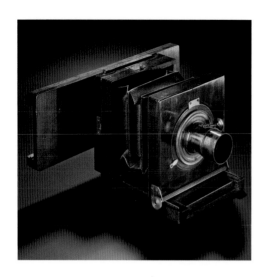

Fig. 5.7

Mahogany bellows camera with a back adapted for cartes-de-visite, French, 1860s.

National Museums Scotland T.1979.19

5.8]. Strips of cartes, still joined together hang from the ceiling to dry, while women cut and adjust the images; on the left a young man puts the glued images placed on card through a press [**Fig. 5.9**]. There is a hand-cranked, cam-operated platen printing press by A. Magand of Paris, as seen in the stereograph: the press automatically feeds, attaches photograph to card, and delivers cartes when the hand crank is turned.

Once the carte-de-visite had 'arrived' in the Victorian drawing-room, it had to be displayed, viewed, and collected into albums. Albums clearly were labour-intensive work, where the cartes were individually identified. Middle and upper-class women were able to devote leisure time to this [**Fig. 5.10**]. As an example, a photograph album entitled *The Queen Album: Views and Flowers of the Riviera*, has coloured decorative plates, and spaces for a mixture of cabinet and carte-de-visite in twenty-four leaves, dating from the 1880s–90s. Four cartes of unidentified subjects are shown opposite a cabinet portrait of Queen Victoria and her youngest daughter, Princess Beatrice. Queen Victoria often enjoyed holidays in the South of France, visiting the Riviera nine times from 1882. For viewing, a lorgnette-style viewer for cartes-de-visite was developed by the instrument makers, Smith, Beck & Beck, London, in the early 1890s. The insertion and removal of individual cartes from the slotted pages of albums could be difficult; use

Figs 5.11 and 12 (left)

Lorgnette-style viewer, by Smith, Beck and Beck, London, c.1890 (left, above) and a pair of Lund's photographic forceps (left, below), c.1880.

Howarth-Loomes Collection at National Museums Scotland IL.2003.44.10.232 and 233

Fig. 5.9 (above left)

Small hand-cranked press, by A. Mangand of Paris, c.1860s.

National Museums Scotland T.1978.80

Fig. 5.10 (above right)

The Queen Album for cartes-de-visite and cabinet photographs.

Howarth-Loomes Collection at National Museums Scotland IL.2003.44.9.313

of devices such as these Lund's forceps prevented damage to the album pages [**Figs 5.11 and 12**].

Before photography, the British were most familiar with their reigning monarch's appearance through the coinage: photography brought a human face to a powerful political and religious symbol. Prince Albert and his advisers quickly appreciated that photography could be used as a means of promoting good public relations. It also made being photographed socially acceptable: if the Queen could be photographed and her

Fig. 5.8 (opposite)

Carte-de-visite production, by an unknown photographer, possibly French, 1860s, stereo albumen prints from a wet collodion negative.

Howarth-Loomes Collection at National Museums Scotland IL.2003.44.6.16.401

 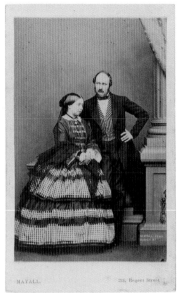 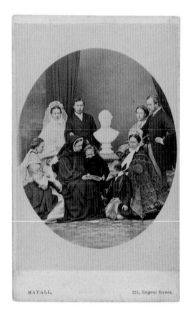

Fig. 5.13

'Her Majesty the Queen', by Charles Clifford, 1861, carte-de-visite.

Howarth-Loomes Collection at National Museums Scotland IL.2003.44.4.666

Fig. 5.14

'Queen Victoria and Prince Albert', by Mayall, London, 1861, carte-de-visite.

Howarth-Loomes Collection at National Museums Scotland IL.2003.44.4.669

Fig. 5.15

'The Royal Family', by Mayall, London, 1863, carte-de-visite.

Howarth-Loomes Collection at National Museums Scotland IL.2003.44.4.659

image sold through shops, then it was acceptable for others. This carte-de-visite, entitled 'Her Majesty the Queen', was published by Cundall, Downes & Co, London, printed on the back: Photographed from life by C. Clifford of Madrid, November 14 1861. This was probably the first image of the Queen taken for public distribution. She wrote in her Journal, that for it she 'dressed in evening dress, with diadem and jewels' [**Fig. 5.13**].[5] Another, earlier image shows the Royal Couple, photographed by Mayall of London in February 1861, and gives no indication of the couple's rank [**Fig. 5.14**]. After Prince Albert's death in December 1861, he continued to feature in family photographs as a portrait bust, as on the occasion of the marriage of the Prince of Wales to Princess Alexandra of Denmark, on 10 March 1863 [**Fig. 5.15**].

This was the beginning of celebrity culture: photography took this to a new level, as the mass production of the carte-de-visite enabled almost anyone to collect pictures of the famous [**Fig. 5.16**]. For example, Charles Darwin (1809–82) was photographed by Ernest Edwards in 1867, and the image published by the London Stereoscopic & Photographic Company. His carte would have been collected as his fame as a naturalist grew. The other side to this was infamy: murderers and imposters. Just as people would scrutinise the faces of the great and the good to discern what elements could make them thus, so they peered into the faces of criminals and wondered whether they could tell what made the face of evil. For example, the carte-de-visite of 'Dr E W Pritchard, His Wife, Mother-in-Law

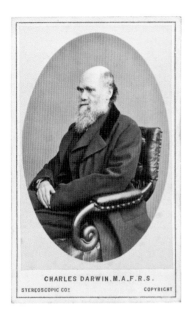

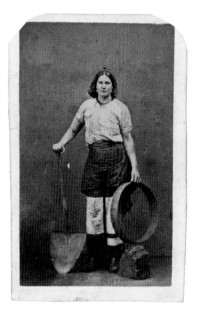

and Family', by Cramb Brothers, of Glasgow, 1865, showed Edward William Pritchard (1825–65), who was notorious for poisoning his wife and mother-in-law. He was the last person to be publicly executed in Glasgow. Another, of the doctor alone, was advertised by Cramb Brothers for 'Price 1 shilling each'. They stated: 'These Portraits are all Copyright, and bear the Publishers' Names. Legal Proceedings will be taken against any one offering *Pirated* Copies for Sale'.[6]

So popular did the carte-de-visite format prove that people were photographed in their work clothes – as opposed to their 'Sunday best' – often to make a point. The variety of occupations identifiable by distinctive costume is not something that we see so much of today. The carte-de-visite 'Sic A Price!' was a posed portrait by Ross & Thomson, of Edinburgh, dating from 1863 [**Fig. 5.17**]. 'Such a price!', the thrifty cook is saying to the Newhaven fishwife, who might well respond with Walter Scott's words: 'It's no fish ye're buying, it's men's lives'.[7] This image can be compared, perhaps unkindly, with Hill and Adamson's earlier photograph of Mrs Elizabeth Hall. Another carte-de-visite shows a portrait of an unidentified female coal worker with a spade and sieve, by John Cooper, Wigan, 1880s. This photographer sold images of 'Pit Brow Lasses' commercially: women continued work at the head of the mines in Lancashire into the 20th century [**Fig. 5.18**].

Fig. 5.16

Charles Darwin, by the London Stereoscopic Company, *c*.1865, carte-de-visite.

Howarth-Loomes Collection at National Museums Scotland IL.2003.44.4.36

Fig. 5.17

'Sic A Price!', a posed portrait by Ross & Thomson, 30 Princes Street, Edinburgh, 1863, carte-de-visite.

Howarth-Loomes Collection at National Museums Scotland IL.2003.44.4.173

Fig. 5.18

Portrait of a female coal worker, by J. Cooper, behind the Royal Oak, Standishgate, Wigan, 1880s.

Howarth-Loomes Collection at National Museums Scotland IL.2003.44.4.133

Printing photographs

Finally accepting that silver images could never be made truly permanent, W. H. F. Talbot sought a way to realise his photographic ambitions using the printer's methods. In 1852, Talbot patented his photographic engraving process, which produced an intaglio plate that could be printed by conventional methods – the final rendering of the photographic image was in stable printer's ink. This was essentially the modern photogravure process, a photographic method without silver. Briefly, he began with a layer of bichromated gelatine (a light-sensitive non-silver material first described by the Edinburgh lawyer Mungo Ponton in 1839) on a metal plate; perhaps more importantly he introduced the use of a screen to enable the accurate reproduction of the halftone areas within an image. Both of these innovations are still used in non-digital reprographics today.

Talbot spent time in Edinburgh from the 1850s, and he was able to draw on its innovative printing industry. By 1858, he had evolved a much-improved process, which he called photoglyphic engraving and a second patent was granted. These were direct ancestors of the modern photogravure process, and while they did not succeed commercially within his lifetime, Talbot's work proved important to the development of this process [**Fig. 5.19**]. While experimenting with his photoglyphic engravings, he discussed suitable specimens with John Hutton Balfour (1808–84), Regius Professor of Botany, based at the Royal Botanical Gardens, Edinburgh. One such letter dated 10 July 1859 reads:

> Some months ago you proposed to dry some of the beautiful ferns in the Bot[l] Garden, for the purpose of photoglyphic Engraving, for which they are eminently calculated – Fronds measuring not more than 9 inches by 7 would be preferred – They should be well expanded, and as nearly as possible without a wrinkle when dried – I believe I sent you the Engraving of an Adiantum which I made the last time I was at home –[8]

The Victorians realised that with improving photograph technology, especially different photo-mechanical processes, they could put photographs on almost any surface: and so they did. For instance, 'The Golden Plover. Wood Carving, by Wallace' [*sic*] was photographed for the International Exhibition of 1862 series by the London Stereoscopic and Photographic Company (probably by their staff photographer William England) [**Fig. 5.20**]. The carver, Thomas Wilkinson Wallis (1802–1903), was compared favourably to the legendary Grinling Gibbons by the Victorian critic John Ruskin; he won medals at the Great Exhibitions of 1851 and 1862 in

Fig. 5.19 (left)

Leaf form by W. H. F. Talbot, *c*.1852, photoglyphic engraving.

National Museums Scotland T.1937.90.6

Fig. 5.21 (right)

'The Golden Plover', by Thomas W. Wallis, by the London Stereoscopic Company, 1863, photograph on a black glass vase.

National Museums Scotland A.970.10

Fig. 5.20 (below)

'The Golden Plover. Wood Carving, by Wallace' [*sic*], by the London Stereoscopic and Photographic Company, 1862, stereo albumen prints from a wet collodion negative.

Howarth-Loomes Collection at National Museums Scotland IL.2003.44.6.15.280

London. This image can be seen on a black glass vase [**Fig. 5.21**] made by J. Powell & Sons (The Whitefriars Glass Company), London: it was presented to the Edinburgh Museum of Science and Art (a forerunner of National Museums Scotland) in 1863.

Another new method of presenting photographs was described as being 'burnt into glass', a technique pioneered by the London photographer, Ferdinand Joubert (1810–84). He was a photographic engraver,

who invented this process, named the phototype (a form of collotype) and this [**Fig. 5.22**] example, 'Proclamation of the Army for Italy, Paris, 1858', by Camille Silvy, was presented by Joubert to the Edinburgh Museum of Science and Art in 1861.

The Stereophotograph

Stereoscopic photography was another public craze. The word 'stereoscopy' derives from the Greek *stereos*, 'firm' or 'solid', and *skopeō*, 'to look' or 'to see'. Any stereoscopic image is called a stereogram. Originally, 'stereogram' referred to a pair of stereo images which could be viewed using a stereoscope. Most stereoscopic methods present two slightly differing images separately to the left and right eye of the viewer. These two-dimensional images are then re-combined by the brain to give the viewer the perception of three-dimensional depth. David Brewster's lenticular stereoscope was developed by a number of manufacturers hoping to cash in on the huge demand for the images. Until the 1870s most stereoscopic images were made from albumen prints using the wet collodion process. With its high definition and brief exposures, good negatives could be obtained from

Fig. 5.22

'Proclamation of the Army for Italy, 1858', by Camille Silvy, Paris 1861, burnt into glass.

National Museums Scotland
T.1861.740.8

Fig. 5.24

Single-lens stereoscopic wet-plate camera, by Thomas Ottewill, London, c.1857.

National Museums Scotland
T.1981.20

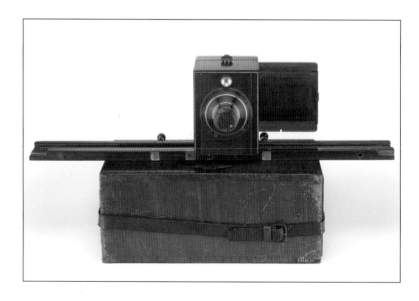

which large numbers of paper positives could be taken. Paper prints and positive glass transparencies were produced to be sold at prices between 1s 6d and 7s 6d (about £6.00 and £30.00 today) depending on quality.

Hundreds of thousands of stereoscopic images were sold by the company in a major craze which reached every middle-class Victorian drawing-room. The demand appeared insatiable. In 1854, George Swan Nottage (1823–85) set up the London Stereoscopic Company. 'No home without a stereoscope' was its slogan. It sold a wide range of stereoscopes, costing from 2s 6d to £20 (about £10 and £1550 today), and became the largest photographic publishing company in the world [**Fig. 5.23**].

Between 1854 and 1860 the London Stereoscopic Company sold thousands of stereographs by many different photographers, both on its staff, and independent. Special cameras were developed to make the images; and a variety of viewers were produced to keep up with demand [**Fig. 5.24**]. This mahogany single-lens sliding box camera has a lens by Andrew Ross, and was made by Thomas Ottewill of Islington, London, in about 1857. To make a stereophotograph, one exposure is made and then the camera is moved across the rail on top of the mahogany carrying-case to take a second consecutive photograph, side by side on a double negative. In due course, Joseph Henry Dallmeyer, Andrew Ross's son-in-law, developed a twin-lens camera [**Fig. 5.25**] that could take two slightly different but simultaneous prints together.

The vast numbers of stereo photographs can be divided into four main categories: travel, news, social scenes and comedy. By far the largest group was that of travel. But although the news photographs would take time to reach the Victorian drawing-room, many were felt to be worthwhile: the incredible diversity of the displayed wares on show at international exhibitions, for instance, could be celebrated without a time limit. Attempts were made to adapt the calotype process for the stereoscope [**Fig. 5.26**], but these proved unsuccessful, possibly because the fibrous nature of the process gave a blurred effect to the print, held only a few inches away from the viewer's eyes. An example, showing a ceramic statue of Napoleon on horseback, survives, by an unknown photographer; the back of the image has the stamp from the Reading Establishment: 'Patent Talbotype or Sun Pictures', dating from the 1850s. A number of ambrotype

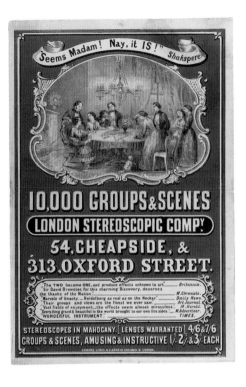

Fig. 5.23

Advertisement for the London Stereoscopic Company, lithograph by Edward Lewis and G. Bohm, London, c.1865.

Howarth-Loomes Collection at National Museums Scotland IL.2003.44.8.41

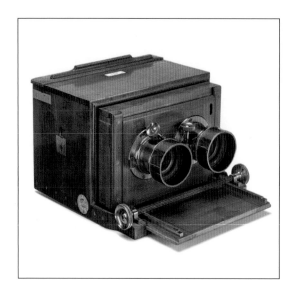

Fig. 5.25

Twin-lens stereoscopic camera, by J. H. Dallmeyer, London, c.1862.

National Museums Scotland T.1967.176

Fig. 5.26 (right and below)

Ceramic statue of Napoleon on horseback, by an unknown photographer, 1850s, stereo salt prints from a calotype negative; with (below) the patent Talbotype stamp from the back of the print..

Howarth-Loomes Collection at National Museums Scotland IL.2003.44.6.14 421 and 421.2

stereophotographs survive, too, although it is unclear why anyone would want to restrict their wet collodion negative to one positive stereo image rather than using it to make multiple albumen prints.

Lenticular viewers came in a number of shapes and sizes, with models made for the luxury end of the market [**Fig. 5.27**] in gold-tooled red leather, as well as inexpensive items, such as the cheap metal hand-held stereoscope [**Fig. 5.28**], described in Sir David Brewster's book *Treatise on the Stereoscope* (1856): 'Japanned Tin Stereoscope, open at sides, front and bottom – 2 shillings and 6 pence'.[9] Other expensive examples were veneered with tortoiseshell, and the most exclusive item was the 'Natural' stereoscope, by John Hirst and Joseph Wood, of Huddersfield, patent no 1611 of 29 May 1862 [**Fig. 5.29**]. This is a large box-type viewer, and only a very few of these de luxe models were made.[10] Sir David Brewster exhibited an example of the Natural Stereoscope on 9 February 1864 to a meeting of the Photographic Society of Scotland where he explained that 'the peculiarity of this beautiful instrument consisted in having an apparatus by which various coloured screens could be introduced behind the transparent picture, which changed the effect from cold to warm or from sun to moonlight.'[11]

From 1858, stereo pairs of photographs were glued into books – the first being by the Astronomer Royal for Scotland, Charles Piazzi Smyth,

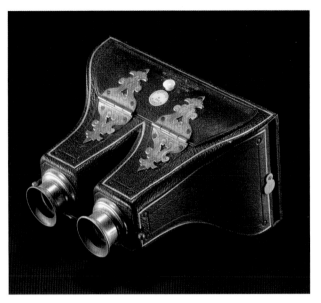

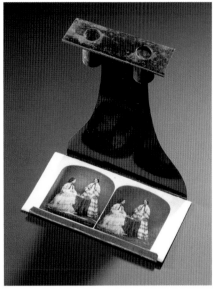

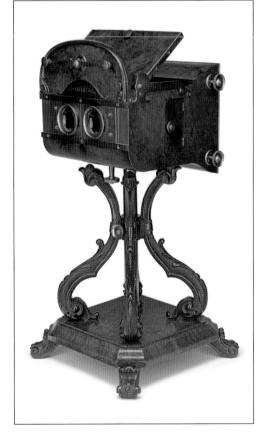

Fig. 5.27 (above left)

Red leather gold-tooled bifurcated Claudet-type stereoscope by Negretti and Zambra, London, c.1865.

IL.2003.44.10.235

Fig. 5.28 (above right)

Cheap metal hand-held stereoscope, 1850s.

IL.2003.44.10.239

Fig. 5.29 (left)

The 'Natural' stereoscope by John Hirst and Joseph Wood, Huddersfield, 1862.

IL.2003.44.10.88

All Howarth-Loomes Collection at National Museums Scotland

SHEEPSHANKS TELESCOPE FIRST ERECTED ON MOUNT GUAJARA, THE PEAK
OF TENERIFFE IN THE DISTANCE.
p.IV.

Fig. 5.30

C. Piazzi Smyth, 'Sheepshanks Telescope', 1856, stereo albumen print from a wet collodion negative, from the first book to be published with stereo pairs.

Howarth-Loomes Collection at National Museums Scotland IL.2003.44.8.159, plate 5

Fig. 5.31

Patent mirror stereoscope, by Smith, Beck & Beck, London, 1859.

Howarth-Loomes Collection at National Museums Scotland IL.2003.44.10.136

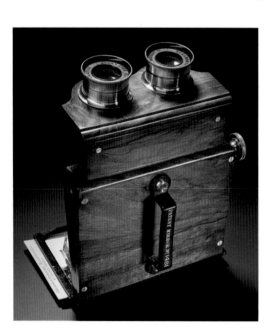

entitled *Teneriffe: An Astronomer's Experiment* (London: Lovell Reeve, 1858) [**Fig. 5.30**]. A patent mirror achromatic hand-held stereoscope, was developed specifically to view stereo pairs of photographs mounted in books, by the London instrument makers Smith, Beck & Beck, from 1859 [**Fig. 5.31**].

George Washington Wilson (1823–93) came from Aberdeenshire, but spent time in both Edinburgh and London training to be an artist. He returned to Aberdeen, where he set up in business with John Hay, a photographer. In 1854, they were invited to go to Balmoral and take photographs for Prince Albert, as he and the Queen were rebuilding their house there [**Fig. 5.32**]. Wilson and Hay soon split up, but Wilson remained with photography. He was considered an exceptional photographer, turning from portraiture to landscape, and using a number of different formats. Wilson was an able businessman, and by the early 1880s his company had become the largest and best-known photographic and printing firm in Scotland. In an obituary of Wilson in 1893, it was said that: 'we know of some who did not disdain to follow Mr Wilson's footsteps in such a literal fashion as, having one of his views in hand, and observing the relation of one portion of scenery to the other,

66

Fig. 5.32

'Balmoral Castle from the N.W.', 1863, by George Washington Wilson, Aberdeen, stereo albumen prints from a wet collodion negative.

Howarth-Loomes Collection at National Museums Scotland IL.2003.44.6.1.132

to eventually by this means discover the identical spot where his camera had been planted, and there also plant their own tripods'.[12] His stereo-scopic images were particularly admired [**Fig. 5.33**]. Wilson had managed to produce a form of 'instantaneous' photographs by 1859, taken in about one-fifth of a second, which greatly appealed to the public. His photo-graphs could register gunfire from ships' cannon [**Fig. 5.34**], or people mov-ing through busy streets: earlier street scenes were eerily empty. Wilson also took bold images into the light, seen in the picture from the inside of Fingal's Cave [**Fig. 5.35**].

The beauty of the English, Welsh or Irish countryside was frequently illustrated, as well as that of Scotland. Rural poverty and derelict cottages were seldom shown, as a Romantic portrayal of scenery prevailed. Views of Regency terraces in cities were more likely to sell than the squalor of Victorian slums or industrial centres. One expert has estimated that more than eight hundred photographers in Victorian Britain are known to have produced commercial stereographic views. Between 1857 and 1863 Francis Bedford (1816–94) produced more than 200 stereo photographs, mostly of Warwickshire. These were well-received at the 1862 International Exhibition in London. He was considered a master of architectural images, in particular [**Fig. 5.36**]. In 1862, he accompanied the young Prince of Wales on a five-month tour of the Middle East, and the royal association certainly did his business no harm. Over the next seven years, he built up a negative library of over 3000 views from all over England and Wales.

William England (1816–96) was the chief photographer for the London

Fig. 5.33

'Abbotsford', 1863.

IL.2003.44.6.1.106

Fig. 5.34

'HMS *Cambridge* in Hamoaze, Great Gun Practice, A Broadside', 1861.

IL.2003.44.6.1.218

Fig. 5.35

'Interior of Fingal's Cave, Staffa', 1863.

IL.2003.44.6.1.75

All by George Washington Wilson, Aberdeen, stereo albumen prints from wet collodion negatives.

Fig. 5.36

'The Butterwalk, Dartmouth, Devon', by Francis Bedford, 1860s.

IL.2003.44.6.8.177

Fig. 5.37

'Le Bristenstock et le Lac d'Uri, Fluelen, Suisse', by William England, 1863.

IL.2003.44.6.1117

Fig. 5.38

'Grandes Crevasses sur la Mer de Glace, Chamoix, Savoie', by William England, 1863.

IL.2003.44.6.1158

All stereo albumen prints from wet collodion negatives.

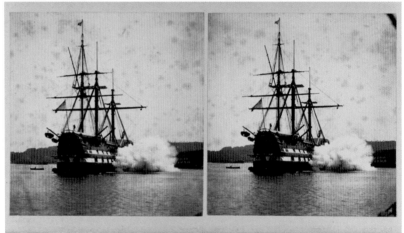

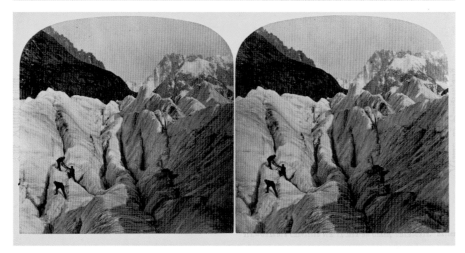

Stereoscopic Company between 1858 and 1863, after which he operated independently. He was an extremely skilled photographer, especially in landscape, architecture, interiors and sculpture. His most notable work was produced in four series: America (1859), Paris (1860 and 1861), the International Exhibition (1862) and the Alpine Club series (1863–68) [**Figs 5.37 and 38**]. Francis Frith (1822–98) produced several hundred early views of England and Wales from 1860, but is chiefly remembered for his Egyptian and Near East series. At the turn of the 19th century, Napoleon's Egyptian campaign had been a military failure, but it provided the foundations for Egyptology and a deep interest of the middle classes in the lands of the Bible and around the Nile. Frith trained as a merchant, but decided after an illness to take some time off, travelling in first Egypt and then the Middle East [**Figs 5.39**]. The photographs he took there were marketed extremely successfully to an eager public, building the basis of his most profitable and long-lasting photography business.

The 19th century saw the expansion of Western European influence across the globe: indeed Victoria became Empress of India in 1877 and at the end of her reign she surveyed an 'empire upon which the sun never sets'. People in Britain became increasingly curious about the places beyond their shores that three-dimensional stereographs could show them. For example, the War Office sent a team of surveyors to the Holy Land in the late 1860s to survey the lands described in the Bible [**Fig. 5.40**], and a Scottish photographer from Edinburgh, Alexander McGlashon, took some of the earliest surviving photographs of Melbourne, Australia [**Fig. 5.41**].

Britain led the world in technology and engineering during Victoria's reign: bridges, railways, sewage infrastructure, and great and radically-new structures such as Joseph Paxton's Crystal Palace grabbed the public's attention and made engineering news. The Royal Albert Bridge across the Tamar between Cornwall and Devon was designed by I. K. Brunel (1806–59). Surveying started in 1848 and construction commenced in 1854. The first main span was positioned in 1857 [**Fig. 5.42**] and the completed bridge was opened by Prince Albert on 1 May 1859. Similarly, the *Great Eastern* captured the public imagination. This massive ship, also designed by Brunel as a passenger vessel, spent most of her career afloat as a cable-laying ship [**Fig. 5.43**]. The scene published by the London Stereoscopic Company is entitled 'The Arrival of the Passenger Train' [**Fig. 5.44**]. Stothert & Slaughter built locomotives in Bristol between 1840 and 1856, when they became Slaughter, Gruning & Co. They subsequently became the Avonside Engine Co. Their entire production was for Great Western Railway and associated local companies, and this particular one is probably No. 28, a standard gauge 0–6–0 built in 1854 for the Monmouthshire Railway,

Figs 5.39 (opposite above) and (middle)

'Panorama of Damascus' and 'The Temple of Koum Ombos', both by Francis Frith, 1858–59, stereo albumen prints from wet collodion negatives.

Howarth-Loomes Collection at National Museums Scotland IL.2003.44.6.10.511 and 393

Fig. 5.40 (below)

Wady Aleyat and Jebel Serbal, by the Ordnance Survey of Sinai (led by Sergeant James McDonald of the War Office), 1869, stereo albumen prints from wet collodion negatives.

Howarth-Loomes Collection at National Museums Scotland IL.2003.44.6.13.183

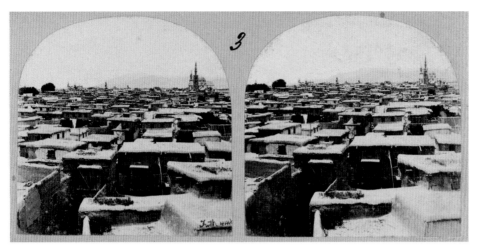

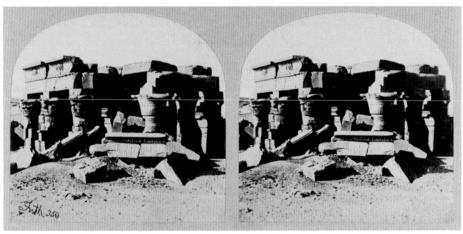

Fig. 5.41

'Collins Street, East, Melbourne', by Alexander McGlashon of Edinburgh, 1857, stereo albumen prints from a wet collodion negative.

Howarth-Loomes Collection at National Museums Scotland IL.2003.44. 6.11.371

Fig. 5.42

'Royal Albert Bridge – East Tube from the West', by William May, Devonport, 1857, stereo albumen prints from a wet collodion negative.

Howarth-Loomes Collection at National Museums Scotland IL.2003.44.6.8.516

Fig. 5.43

'The *Great Eastern*', by Robert Howlett and George Downes, London, 1857, stereo albumen prints from a wet collodion negative.

Howarth-Loomes Collection at National Museums Scotland IL.2003.44.6.13.134

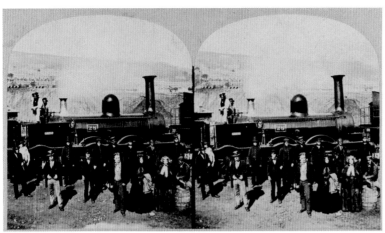

Fig. 5.44

'Arrival of Passenger Train', sold by the London Stereoscopic Company, 1854–56, stereo albumen prints from a wet collodion negative.

Howarth-Loomes Collection at National Museums Scotland IL.2003.44.6.16.141

Fig. 5.45

'The Great Exhibition – taken on the Day of Opening', 1 May 1862, by an unknown photographer.

Howarth-Loomes Collection at National Museums Scotland IL.2003.44.6.15.58

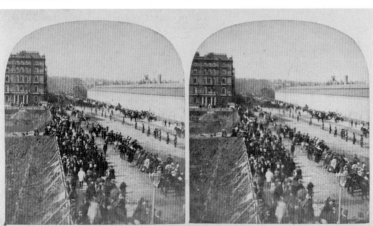

Fig. 5.46

Material lent by the Northern Lighthouse Board to the International Exhibition of 1862, stereo albumen prints from a wet collodion negative.

Howarth-Loomes Collection at National Museums Scotland IL.2003.44.6.15.261

running between Newport and Pontypool. The Great Western took over the Monmouthshire Railway in 1875 and this engine became G.W.R. locomotive no. 1329 before being scrapped in 1884.[13]

After the enormous success of the Great Exhibition of 1851, a number of similar shows were held at intervals in the major capitals of the western world. These showcased the cutting-edge products as well as the art of the time, and were seen by the public as entertainment as well as educational. A rare view, showing the crowds on the opening day, 1 May 1862, of the outside of the International Exhibition, held in London, shows how popular these events were [**Fig. 5.45**]. Another view [**Fig. 5.46**] shows material lent to the exhibition by the Northern Lighthouse Board, Edinburgh, now in the collections of National Museums Scotland.

Posed comedy scenes were often based on topical humour, to be found, for instance, within the pages of the satirical magazine *Punch*. Actors or models were employed by the photographer, and arranged in appropriate garb on a stage set illustrating, for example, a picnic, a harem, or a ballroom. Many photographers, among them James Elliott and Alfred Silvester, produced admirable examples, although some of their imitators produced vulgar and poorly-made views. 'The Orphan's Dream' [**Fig. 5.47**], by James Elliott, *c*.1857, shows an effect suggested by Sir David Brewster. This uses a partial exposure to create the illusion of a spirit figure. The ghostly effect was obtained by allowing the model to pose in front of the camera for only a moment. 'Returning from the Derby [*Le Retour des Courses*]' [**Fig. 5.48**], by Alfred Silvester, 1859, was one of a series of posed images on this theme produced by Silvester, inspired by the showing of W. P. Frith's narrative painting, 'The Derby Day', exhibited at the Royal Academy exhibition in 1858.[14] 'Putting on a Crinoline' [**Fig. 5.49**], by an unknown photographer, 1857, was part of a series 'Mysteries of the Crinoline', published by the London Stereoscopic Company. The crinoline was lampooned in *Punch* as a ludicrous fashion.

Paper transparencies – or French tissues – were sometimes neither 'French' nor 'tissues'. Introduced in the early 1860s, the photographs were printed on extremely thin paper and backed with another piece on which the outline of the photograph was painted in various colours. When viewed by reflected light, the picture was seen as a normal photograph, but when seen by transmitted light the scene appeared in colour. A further embellishment was to pin-prick such features as candles or jewellery which then showed as sharp points of light when seen backlit in the stereoscope. This image of Edinburgh – 'View of Waverley Bridge, Edinburgh' [**Fig. 5.50**] – is by a photographer who has not been identified, 1860s, and it was sold by Lennies, who had a shop on Princes Street.

Fig. 5.47

'The Orphan's Dream', by James Elliott, *c.*1857, stereo albumen prints from a wet collodion negative

Howarth-Loomes Collection at National Museums Scotland IL.2003.44.6.7.61

Fig. 5.48

'Returning from the Derby', by Alfred Silvester, 1859, stereo albumen prints from a wet collodion negative

Howarth-Loomes Collection at National Museums Scotland IL.2003.44.6.7.262

Fig. 5.49

'Putting on a Crinoline', by an unknown photographer, 1857, stereo albumen prints from a wet collodion negative

Howarth-Loomes Collection at National Museums Scotland IL.2003.44.6.6.28

For making paper prints, the normal printing-out process used in the wet collodion process was followed for developing; but for the production of positive glass slides, the method pioneered by Louis Désiré Blanquart-Évrard (1802–72) was found to be more effective. After a brief exposure, the latent image on the glass plate was developed and fixed. The quality of the glass slide was usually superior to the paper print, reflected in its higher retail price. Charles Breese (1819–75) of Birmingham and Sydenham sold his highly thought-of quality slides at 5 shillings (£20 today) each [**Fig. 5.51**]. Entitled 'Breaking Waves', 1870s–80s, it comes with a quote from Lord Byron: 'Sea with rocks and half moon / the deep blue moon of night, Lit by an orb, / Which looks like a spirit or a spirit's world'.

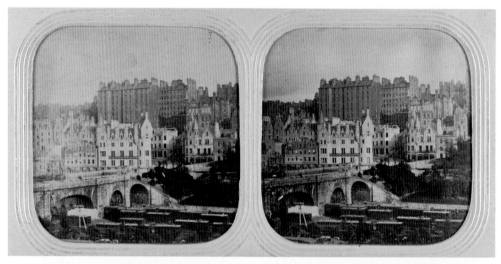

Notes

1. Quoted in Julie Lawson, Ray McKenzie and A. D. Morrison-Low (eds.) 1993. *Photography 1900: The Edinburgh Symposium* (Edinburgh: National Museums of Scotland and National Galleries of Scotland: 1993), 28: from National Archives of Scotland, Papers of the Photographic Society of Scotland [GD 356/12/71], letter from John Adamson dated 29 November 1861.

2. Quoted by Helmut Gernsheim, *Julia Margaret Cameron: Her Life and Photographic Work* (New York: Fountain Press, 1984), 20.

3. From: Andrew Wynter, 'Carte-de-visite', reprinted in *Curiosities of Toil and Other Papers*, 2 volumes (London: Chapman and Hall, 1870), I, 134.

4. Quoted by Helmut Gernsheim, *Julia Margaret Cameron: Her Life and Photographic Work* (New York: Fountain Press, 1984), 25.

5. Quoted by Frances Dimond, 'Queen Victoria's portrait collection', in Frances Dimond and Roger Taylor, *Crown & Camera: the Royal Family and Photography 1842–1910* (Harmondsworth: Penguin Books, 1987), 67–9.

6. *Glasgow Herald*, 15 July 1865.

7. Walter Scott, *The Antiquary* (Edinburgh: Archibald Constable & Co.: 1822), 181.

8. Talbot to Hutton Balfour, letter dated 10 July 1859: <http://foxtalbot.dmu.ac.uk/letters/transcriptDocnum.php?docnum=7664> (Letter 7664, Talbot to Hutton Balfour, 10 July 1859).

9. David Brewster, *Treatise on the Stereoscope* (1856), Supplement, 14.

10. Paul Wing, *Stereoscopes: The First One Hundred Years* (Nashua, NH: 1996), 41–3.

11. Report of a meeting of the Photographic Society of Scotland, *Journal of the Photographic Society of London* 8 (1864): 459.

12. Obituary, *British Journal of Photography* 40 (17 March 1893): 165–6.

13. My thanks to Andy King of Bristol Museums for the identification of this locomotive.

14. Many of these images, their stories and derivations, are discussed by Denis Pellerin and Brian May, *The Poor Man's Picture Gallery: Stereoscopy Versus Paintings in the Victorian Era* (Exeter: The London Stereoscopic Company, 2014).

Fig. 5.50 (opposite, above)

'View of Waverley Bridge, Edinburgh', by an unknown photographer, 1860s, stereo albumen prints from a wet collodion negative.

Howarth-Loomes Collection at National Museums Scotland IL.2003.44.6.2.204

Fig. 5.51 (below)

'Breaking Waves', by Charles Breese & Co., Sydenham, 1870s–80s, positive glass stereograph.

Howarth-Loomes Collection at National Museums Scotland IL.2003.44.7.398

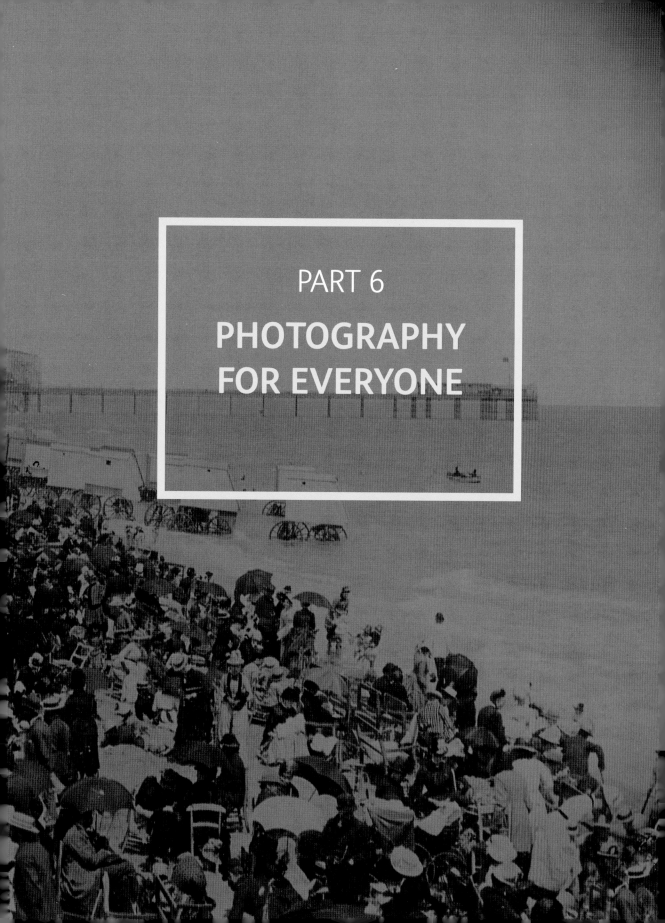

PART 6

PHOTOGRAPHY
FOR EVERYONE

'What do you look on as the greatest boon that has
been conferred on the poorer classes in later years?' …
I am afraid that I sunk in his estimation when
I answered 'sixpenny photographs' … [it] is owing more
for the poor than all the philanthropists in the world.

*

Photographic News 15 (10 November 1871), page 340

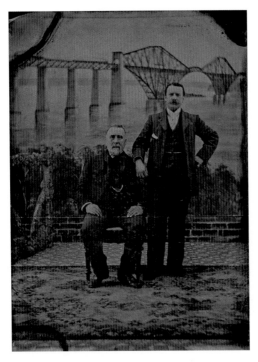

FERROTYPES, or tintypes, introduced by Adolphe-Alexandre Martin in 1853, were collodion positives on tinned or enamelled iron. It was a process used a lot by itinerant photographers, although much more appreciated and successful in the United States. In Britain, even the professional photographic press regarded it as bottom of the market. A number of photographers used the tintype process in the studio [**Figs 6.1a and b**]. Despite the poor quality of many of the images that resulted from using this process, tintypes enjoyed a long run of popularity, and were still being produced well into the 20th century, especially by beach photographers. The finished photograph could be handed to the customer within minutes, and prices were seldom above 6d (about £2 today).

The seaside had been a fashionable resort for the wealthy from the 18th century. But the arrival of the railways and steamers meant that many more could escape for a day on the beach; and with the Bank Holidays Act of 1871, entire families could take a weekend away – and they naturally wanted a souvenir of the occasion to bring home with them.

In putting this exhibition together, it was spotted that there was a story to be told about a group of tintypes in the Howarth-Loomes Collection, some of which had been given to the Kodak Collection and had gone to the National Media Museum. It appeared that the same family had gone on holiday to the same resort – one of us worked out that it was Margate from the lettering on a small boy's bucket in one of the images – for a number of successive years [**Figs 6.2 a and b**]. As the boys grew older, they and their parents were joined by a younger sibling. Here we reunite these annual mementoes, which had clearly been disposed of as a group together. We will never know more than these magic windows into a long-ago series of family annual seaside trips.

The seaside scene overleaf [**Fig 8.3**] shows a number of beach photographers. It was taken by Poulson of Ramsgate in 1882. Many of the photographers in this picture would have been using the tintype for a souvenir sale to the day-trippers. The scene has been identified as Ramsgate: the Chatham and Dover Railway terminus can be seen almost on the shore, to allow ease of access for visitors.

Pages 78–79 (detail)

Seaside scene showing beach photographers, 1882, by Poulson of Ramsgate.

Howarth-Loomes Collection at National Museums Scotland IL.2003.44.9.371

Figs 6.1 a (opposite left) and b (right)

(a) Two unidentified men in front of a studio backdrop of the Forth Bridge, by Peter McGill, Hawes Pier, South Queensferry, c.1900, tintype; and (b) the McBride family, 1881–1900, tintype by Ovinius Davis, 16 Princes Street, Edinburgh.

Howarth-Loomes Collection at National Museums Scotland IL.2003.44.3.31 and 90

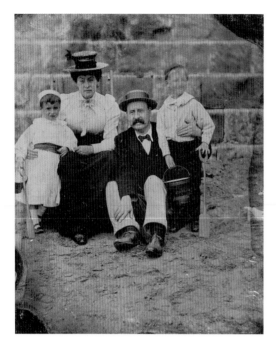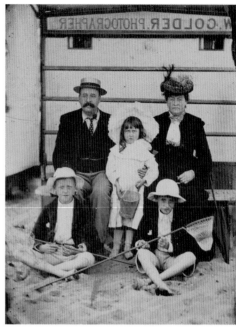

Figs 6.2a (left) and b (right)

Unidentified family group on the beach: (a) with two boys with buckets and spades, tintype by unknown photographer, Margate; and (b) with two boys with fishing nets and a girl with a bucket, by W. Colder, both images 1880s–90s.

Howarth-Loomes Collection at National Museums Scotland IL.2003.44.3.30 and 50

Fig. 6.3 (right)

Seaside scene showing beach photographers, 1882, albumen print from a wet collodion negative, by Poulson of Ramsgate.

Howarth-Loomes Collection at National Museums Scotland IL.2003.44.9.371

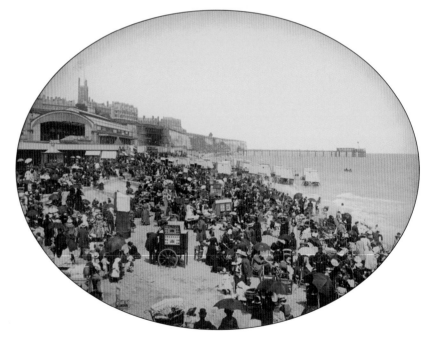

BY the last two decades of the 19th century, photography for photography's sake was being practised by a number of artists, using newer processes that had emerged in later years. Here is a selection.

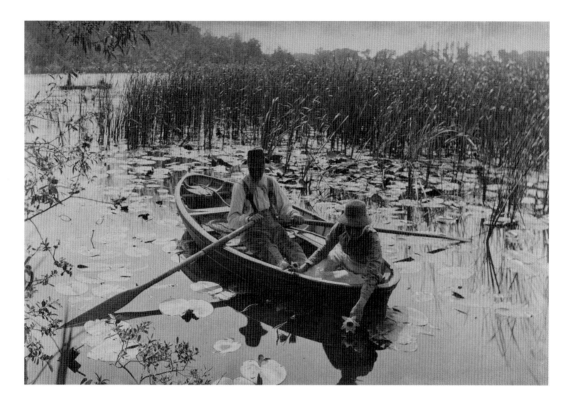

**Peter Henry Emerson, 'Gathering Water Lilies'
1886, platinum print**

Emerson (1856–1936) encouraged photography as an art-form. Influenced by the contemporary naturalism of French painting, he argued for similar naturalism in photography. This led to his sharp focus recording of country life. His first album of photographs was entitled *Life and Landscape on the Norfolk Broads* (1886), and consisted of forty platinum prints, including this one. The woman is gathering water lilies to place in a trap for tench, a fish found in the local waters.

Soon, Emerson found his sharp-focus views too undiscriminating, and moved towards a more selective way of capturing his images that emulated how the human eye sees the world.

Howarth-Loomes Collection at National Museums Scotland
IL.2003.44.9.514

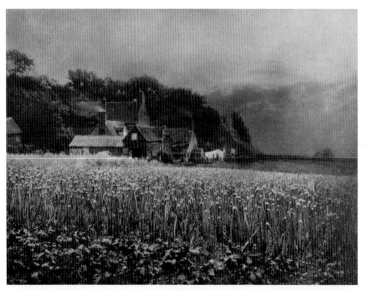

George Davison
'The Onion Field'
1890, photogravure

George Davison (1854–1930) was an advocate of impressionist photography, but also a successful businessman as a managing director of Kodak UK. Early in his photography he was influenced by Peter Henry Emerson, but soon rejected the 'naturalist' sharp focus effect. Instead, he turned to using a pinhole camera (without a lens), and in 1890 made this painterly image, which became extremely controversial.

Howarth-Loomes Collection at
National Museums Scotland
IL.2003.44.9.64

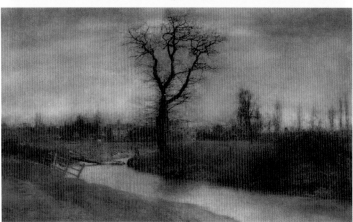

George Davison
'Winter landscape: solitary tree by a bend'
photogravure, 1910

Davison's work, beginning with 'The Onion Field', set up a controversy in photographic circles, in which 'fuzzy' photographs were contrasted with 'sharp' ones. The *Amateur Photographer* magazine remarked that: 'Perhaps the chief feature of the present collection is the evidence it gives of the marked advance and influence of what may be termed the "school of foggy photography".'

Howarth-Loomes Collection at
National Museums Scotland
IL.2003.44.9.65

84

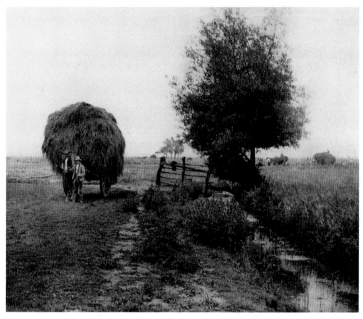

**Peter Henry Emerson
'In the Haysel'
1888, photogravure print**

This photograph originally appeared in 1888 as the frontispiece to Emerson's *Pictures of East Anglian Life*. Subsequently, he published a portfolio of photographs from this series in 1890. There Emerson explained how they illustrated his theory that photographers should use selective, or 'differential', focus to record the effects of nature. Of this image he remarked, 'it is not perfectly "sharp" in any part and the hay-carts in the distance are as sharp as they should be'.

Howarth-Loomes Collection at
National Museums Scotland
IL.2003.44.9.12

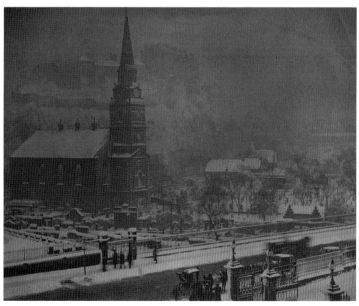

**Frank P. Moffat
St Cuthbert's Church, Lothian
Road, Edinburgh
1882, platinum print**

Moffat (c.1853–1912) inherited the family photography business in Edinburgh from his father, John, in 1894. When photographic portraiture was becoming both cheaper and more elaborate, Moffat concentrated on the upper end of the market, building up a business founded upon 'high class portraiture – not upon low prices'. This photograph shows the junction of Lothian Road and Princes Street in Edinburgh before the Caledonian Station and Hotel were built.

Howarth-Loomes Collection at
National Museums Scotland
IL.2003.44.9.179

FURTHER READING

Brusius, M. et al. (eds) 2013. *William Henry Fox Talbot: Beyond Photography* (London and Newhaven: Yale University Press).

Buerger, Janet E. 1989. *French Daguerreotypes* (Chicago and London: University of Chicago Press).

Dimond, Frances and Roger Taylor 1987. *Crown & Camera: the Royal Family and Photography 1842–1910* (Harmondsworth: Penguin).

Howarth-Loomes, B. E. C. 1974. *Victorian Photography: a Collector's Guide* (London: Ward Lock Limited).

Pellerin, Denis and Brian May 2014. *The Poor Man's Picture Gallery: Stereoscopy Versus Paintings in the Victorian Era* (Exeter: The London Stereoscopic Company).

Simpson, Roddy 2012. *The Photography of Victorian Scotland* (Edinburgh: Edinburgh University Press).

Smith, Graham 1990. *Disciples of Light: Photographs in the Brewster Album* (Malibu: The J. Paul Getty Museum).

Stevenson, Sara 2002. *The Personal Art of D. O. Hill* (New Haven and London: The Paul Mellon Centre for Studies in British Art by Yale University Press).

Stevenson, Sara and A. D. Morrison-Low 2015. *Scottish Photography: The First Thirty Years* (Edinburgh: National Museums Scotland).

Taylor, Roger 1981. *George Washington Wilson, Artist and Photographer, 1823–93* (Aberdeen: Aberdeen University Press in association with the University of Aberdeen).

Wing, Paul 1996. *Stereoscopes: The First One Hundred Years* (Nashua, NH: Transition Publishing).